amazing
Crayon Drawing
with Lee Hammond

CREATE LIFELIKE PORTRAITS, PETS, LANDSCAPES & MORE

NORTH LIGHT BOOKS
CINCINNATI, OHIO
www.artistsnetwork.com

Table of Contents

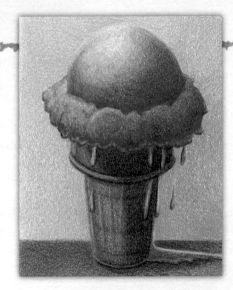

5 Introduction

6 All About Crayons

7 Applying Crayon

8 Before & After

CHAPTER 1

10 Getting Started

CHAPTER 2

16 Techniques

CHAPTER 3

36 Cylindrical & Round Objects

CHAPTER 4

48 Textures

CHAPTER 5

62 Nature

CHAPTER 6

78 Animals

CHAPTER 7

92 People

100 Gallery

107 Conclusion

108 About the Author & Acknowledgments

110 Index

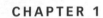

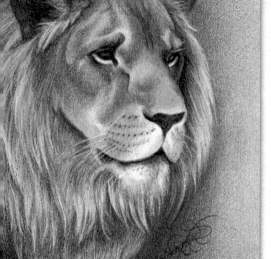

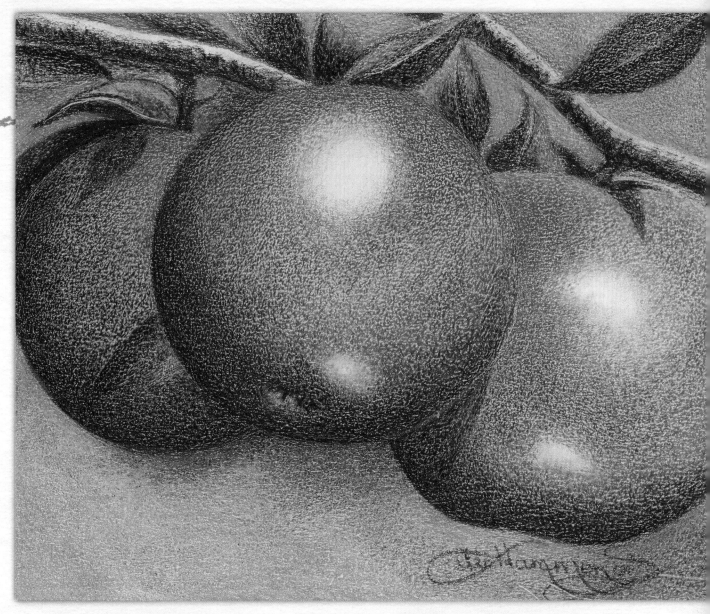

DEDICATION

This book is dedicated to everyone who remembers the wonderful feeling of opening up a brand new box of crayons! For artistic types, few things are as exciting and creatively stimulating.

Crayons are not just for children. They are for all of you, regardless of your age, who are young at heart. They are for all the artists who allow their inner child to run free from time to time. I hope you are one of them. I know I am!

Study of Apples
Crayon on #1008 Ivory mat board, 8" × 10" (20cm × 25cm)

COLORS USED: (apples) Black, Brick Red, Green, Orange, Pine Green, Red Orange, White, Yellow, Yellow Green; (branches) Black, Shadow; (leaves) Green, Black; (background) Green, Mango Tango, Orange, Shadow, Yellow Orange

Introduction

I WAS ONLY FIVE YEARS OLD, BUT I REMEMBER IT LIKE IT WAS YESTERDAY.
I was sitting at the kitchen table eating my oatmeal before leaving for kindergarten. My mother was in the kitchen doing the dishes. I vividly remember the sound of water running and dishes clanking in the sink, and my mom's neatly tied apron around her waist.

I always watched Captain Kangaroo, and during the show, Captain Kangaroo always stopped to do a promotion for Crayola Crayons, since he was their spokesperson. On this morning, he held up drawings that were created in crayon. They had obviously been drawn by a professional, and I remember my mouth falling open when I looked at them. The first drawing he showed was of a zebra in just black and white, but the drawing was shaded and realistic. To my youthful eyes it was like looking at magic. The second drawing was of a rainbow trout, and it was awesome. Even though we had only a black-and-white television at the time, you could still see the changing tones that represented the colors. It looked like it was gleaming and was actually wet, and the curve of the fish looked so realistic.

I jumped up from my chair and said, "Look, Mommy! I'm going to draw like that someday!" She came into the room, wiping her hands on her apron and smiled as she said, "Then I believe you will." The rest, as they say, is history!

So, why was I so hyped up to write a book about crayons? Perhaps it was my inner child screaming at the top of her lungs, a desire to reconnect with my authentic, youthful creativity. Whatever it was, I had a blast creating this book, and I cannot recommend crayons enough if you want to have fun with your art.

So grab a brand new box of crayons, and follow along to create some fun drawings. You will be amazed with the results, and you will learn some great new tricks you can pass along from generation to generation.

I hope that this book will change the way people draw with crayons forever. It would be my dream come true for a child to see this book and have the same reaction I did when I saw the segment on Captain Kangaroo half a century ago, and say, "Mommy, I want to draw like Lee Hammond!"

Zebra
Crayon on regular surface 2-ply Bristol, 14" × 11" (36cm × 28cm)

COLORS USED: (zebra) Beaver, Black, Blue Green, Brown, Green, Shadow, Tan;
(background) Black, Blue Green, Green, Pine Green, Robin's Egg Blue, Sky Blue;
(any white in the drawing is the white of the paper showing through)

All About Crayons

For over a century, crayons have been children's first method of graphic communication, a way of visually representing their world. Given a box of crayons, all children seem to innately know what to do with them.

Many people find it odd that I teach crayon drawing in my studio. Naturally, they assume I am teaching small children. But I am not. I use crayons as a quality fine art medium. They have high-quality pigments and use high-quality wax as a binder. Most of the colors have the same lightfast qualities as your more expensive colored pencils, but I love the hallmark look that is not achieved with anything but crayons.

The first thing to remember when working with crayons is that you are not going "backwards." Yes, they are inexpensive to buy, but they are NOT cheap. However, I do suggest using the original brand, Crayola. While there are many other brands out there, I find that Crayola is the best for professional use due to its richly pigmented colors. The bargain brands are a bit heavier on the wax, which is fine for kids, but the colors are not as rich.

When teaching my students how to draw with crayons, I have to keep reminding them that while some of the techniques are similar to colored pencils, the look is unique. Please, please, do not try to compare the two! Do not try to beat them into submission to make them look like colored pencil. If that is the look you want, simply use colored pencils instead. You must accept and embrace the differences, and allow crayon to be crayon. The result is a wonderfully unique piece of art that only crayons can produce.

TREAT CRAYONS AS A FINE ART MEDIUM
Once you rearrange your thinking and begin using crayons as a fine art medium, you will be on your way to creating a piece like this.

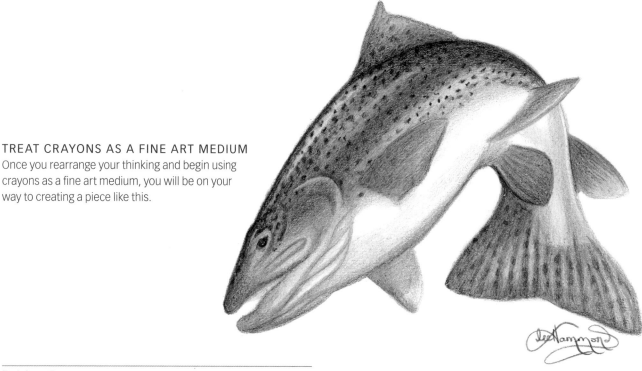

Rainbow Trout
Crayon on regular surface 2-ply Bristol, 11" × 14" (28cm × 36cm)

COLORS USED: Black, Brown, Cadet Blue, Carnation Pink, Magenta, Olive Green, Periwinkle, Robin's Egg Blue, Sea Green, Tan, Tropical Rain Forest, Yellow (now you know why they call them rainbow trout!)

Applying Crayon

I often use my colored pencil techniques with crayon, but the results are quite different. The similarity is that I use layering and burnishing for creating different looks.

While the two pieces of fruit here were drawn using the same shape and the same colors, the application changes their appearance. The first one was done with layering, which makes it look like a peach. The second one was done with burnishing, which makes it look like a nectarine. This is my favorite example for showing the differences in the two techniques.

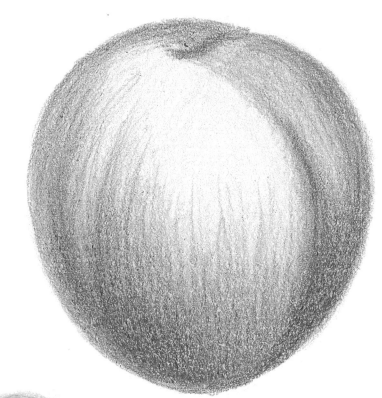

LAYERING
Layering crayon makes this one look like a peach with soft, fuzzy skin.

BURNISHING
Burnishing crayon makes this one look like a nectarine with a bright, smooth surface.

Before and After

I find it amazing how much psychology influences our artistic abilities. When I introduced my art students to crayon drawing, they were amazed at the results and wanted to try it themselves, but even my most talented and professional artists regressed to childlike behavior when a crayon was gripped in their hands. Instead of treating the crayon as a serious tool, they applied it with rough fill-in and scribbled lines. You must approach your crayon drawing as if you were using any other professional art medium.

BEFORE
This is one of my student's first attempts at drawing realistically with crayons. The application of color shows she had reverted back to coloring without even knowing it. Everything looks flat and merely filled in.

She also used an ordinary piece of paper, not a good quality paper or board. This fuels the regression, by treating the crayon as a toy, not a fine art product.

AFTER
Her second attempt looks quite different. This time she used a piece of mat board that has a texture to it, which helps create a unique look.

Rather than just filling in each area with flat color, she used layering and a wider range of color to make it look much more professional.

Artist, Kay Lewis
Crayon on illustration board

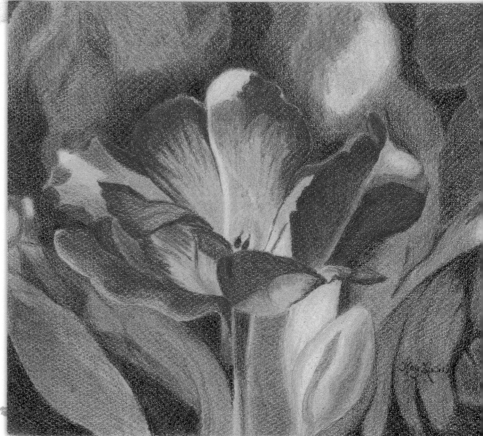

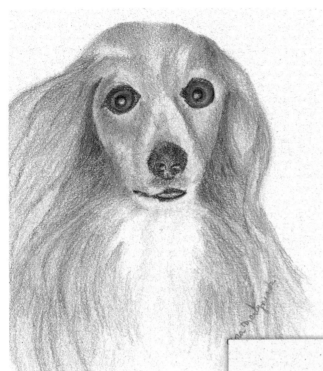

BEFORE

Another student of mine drew from a photograph of my pet, Penny the Wonder Dog. The colors in her first attempt appear very light, showing she was unsure of how to apply them. Her shapes were not very accurate either.

The photo she used was the same one I used for my drawing of Penny in the Techniques section. In my drawing, Penny is posed at a slight turn, showing the side of her face. In this drawing, she is shown straight on. This is not uncommon. Our mind's eye always wants to straighten everything up to make things symmetrical.

AFTER

In this second drawing, her technique is much better. The colors are more brilliant, and there is a clear definition of the fur. Here you can see the layers of fur and the actual length of the hair. However, she still straightened the face as she drew. It is hard to overcome our own brains and the way we perceive things.

Artist, Nora Martyniak
Crayon on Beachsand Ivory Artagain
drawing paper

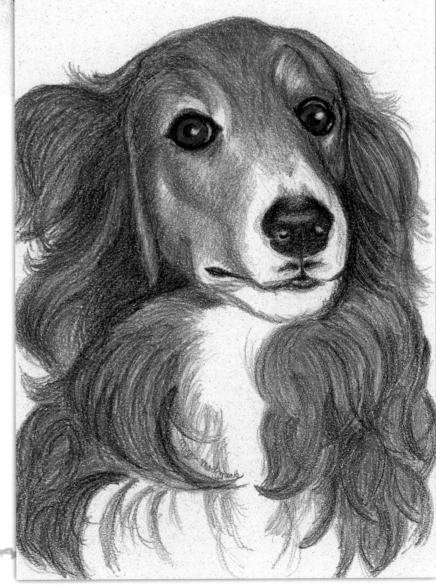

Visit www.artistsnetwork.com/newsletter_thanks for a free download of *The Artist's Magazine*.

9

Getting Started

THE BEST PART OF DRAWING WITH CRAYONS IS THAT YOU DO NOT need to invest a lot of money to be successful with it. Even the largest set of crayons is more affordable than the smallest set of good colored pencils.

As you familiarize yourself with the crayons, you'll notice that different pigments have different characteristics. Some of the colors are quite rich and opaque. This means that when they are applied to the paper, they cover it completely with a rich saturation of color. These are great for intense color and bright subject matter.

Some colors, however, are more transparent. When they are applied to the paper, the color barely shows, and they seem to be more wax than pigment. Try each color on a separate piece of paper to see how it looks. Often, what shows on the paper is not what the crayon looks like in stick form.

Experiment with the colors to see how they look when applied lightly, and how they look when applied heavily. See what they look like when applied over one another, and practice some value scales.

Even a single black crayon can create a dramatic drawing if applied the right way. I often recommend starting off with only one color, just to get the feel of the crayons again, and to help retrain your brain in the way you think about them.

Draw Portraits With Lee

Watch a free video preview from *Drawing Lifelike Portraits With Lee Hammond* at http://AmazingCrayon Drawing.artistsnetwork.com.

EXPERIMENT WITH COLOR

Lavender Vase With Flowers
Crayons on illustration board, 12" × 9" (30cm × 23cm)

COLORS USED: (vase) Black, Blue Green, Orchid, Outer Space, Periwinkle, Plum, White; (flowers) Blue Violet, Carnation Pink, Orchid, Plum, Red Violet, Violet, White; (vines) Black, Fern, Green, Olive Green, Pine Green; (background) Bittersweet, Black, Brick Red, Brown, Goldenrod, Melon

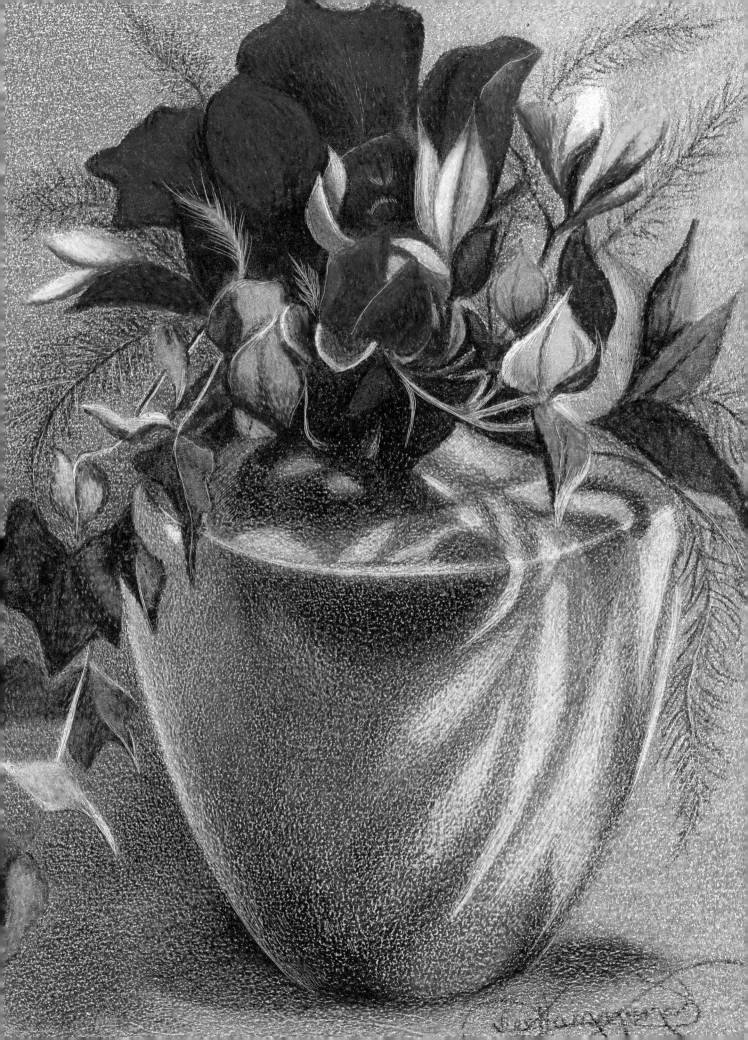

The Colors

The following pages show the variety of colors available in the Crayola line of crayons. Each swatch shows the color as it looks when applied lightly (on the left side), and how it looks when applied heavily (on the right side).

Use these swatches for color reference as you draw. This will help you choose the right color for your project.

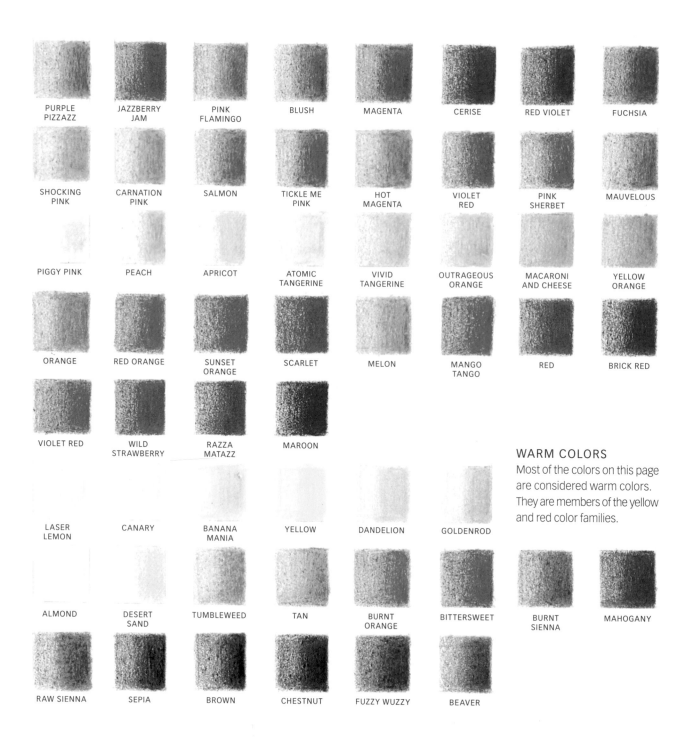

PURPLE PIZZAZZ JAZZBERRY JAM PINK FLAMINGO BLUSH MAGENTA CERISE RED VIOLET FUCHSIA

SHOCKING PINK CARNATION PINK SALMON TICKLE ME PINK HOT MAGENTA VIOLET RED PINK SHERBET MAUVELOUS

PIGGY PINK PEACH APRICOT ATOMIC TANGERINE VIVID TANGERINE OUTRAGEOUS ORANGE MACARONI AND CHEESE YELLOW ORANGE

ORANGE RED ORANGE SUNSET ORANGE SCARLET MELON MANGO TANGO RED BRICK RED

VIOLET RED WILD STRAWBERRY RAZZA MATAZZ MAROON

WARM COLORS

Most of the colors on this page are considered warm colors. They are members of the yellow and red color families.

LASER LEMON CANARY BANANA MANIA YELLOW DANDELION GOLDENROD

ALMOND DESERT SAND TUMBLEWEED TAN BURNT ORANGE BITTERSWEET BURNT SIENNA MAHOGANY

RAW SIENNA SEPIA BROWN CHESTNUT FUZZY WUZZY BEAVER

Learn more at http://AmazingCrayonDrawing.artistsnetwork.com.

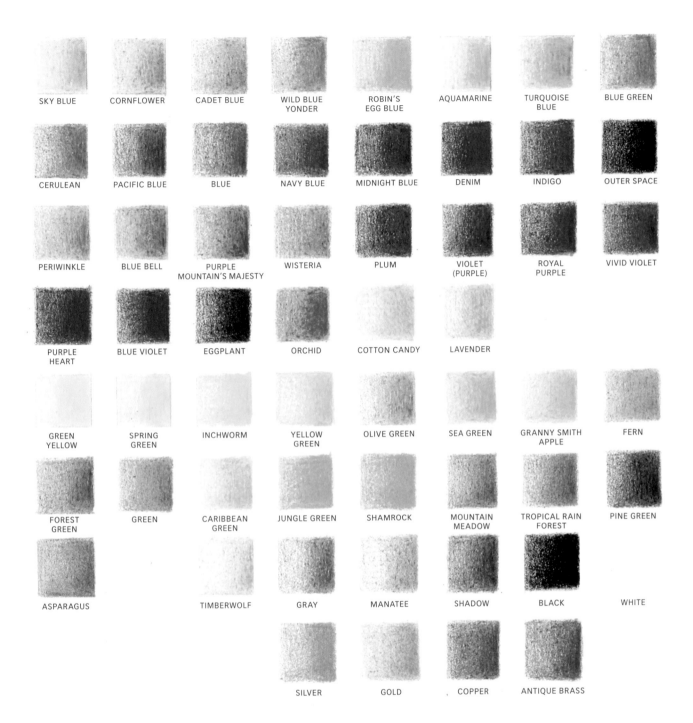

SKY BLUE CORNFLOWER CADET BLUE WILD BLUE YONDER ROBIN'S EGG BLUE AQUAMARINE TURQUOISE BLUE BLUE GREEN

CERULEAN PACIFIC BLUE BLUE NAVY BLUE MIDNIGHT BLUE DENIM INDIGO OUTER SPACE

PERIWINKLE BLUE BELL PURPLE MOUNTAIN'S MAJESTY WISTERIA PLUM VIOLET (PURPLE) ROYAL PURPLE VIVID VIOLET

PURPLE HEART BLUE VIOLET EGGPLANT ORCHID COTTON CANDY LAVENDER

GREEN YELLOW SPRING GREEN INCHWORM YELLOW GREEN OLIVE GREEN SEA GREEN GRANNY SMITH APPLE FERN

FOREST GREEN GREEN CARIBBEAN GREEN JUNGLE GREEN SHAMROCK MOUNTAIN MEADOW TROPICAL RAIN FOREST PINE GREEN

ASPARAGUS TIMBERWOLF GRAY MANATEE SHADOW BLACK WHITE

SILVER GOLD COPPER ANTIQUE BRASS

Lee's Lessons

It is important to get to know colors and understand their traits. Warm colors are often used to reflect light off of subjects and will appear to come forward. Cool colors are often used in shadow and appear to recede. Study the examples throughout the book and see how warm and cool colors are used.

COOL COLORS

Most of the colors on this page, with the exception of the metallic colors, are considered cool colors. They are from the green and violet color families.

Materials

Drawing with crayons may seem simple, but there are many other tools that you need to create professional work with them. The following is a list of supplies you need to succeed.

Paper

Quality paper is very important. Each type will produce a different look, and there is no "right" paper to use for crayon. There are many fine papers to choose from, so experiment to find your personal favorites.

The only type of paper I steer away from is the type I use for graphite drawing, called smooth Bristol. It has a very polished, smooth surface and is just too slick to hold the crayon properly. Regular Bristol, however, works great. Look for paper with a tooth so it can accept the wax evenly. I also recommend a paper that is somewhat heavy. Lightweight paper can buckle under pressure or get creased by crayon.

My favorite surfaces include:

- *Stonehenge paper*: It is a white high-quality paper that has a good weight to it. Many of the drawings in this book were done on it.

- *Artagain by Strathmore*: It has a speckled appearance with no noticeable texture to it.

- *Crescent mat board*: It is very firm and also comes in a variety of colors, as well as a range of surfaces, from smooth to highly textured.

Sharpener

Crayons become blunt very quickly when you are drawing with them. To keep them sharp requires a good handheld sharpener.

Most of the handheld sharpeners have only one hole that is often too small for a crayon. Use a tungsten steel handheld sharpener; or look for sharpeners that have two holes, and use the larger one. It helps to peel the paper down before you sharpen your crayon.

Never use an electric or battery-operated sharpener for crayons. Crayons are simply too soft and will break off in the sharpener.

Erasers

Although crayons are difficult, if not impossible to completely erase, erasers can be used to soften colors.

Here are some you will find useful:

- *Kneaded eraser*: This eraser is like a squishy piece of rubber that resembles clay. It's a gentle eraser that will not rough up or damage your paper. You can use it for removing your initial line drawing as you work. It is also good for dabbing up the little specks that come from the crayons as you work.

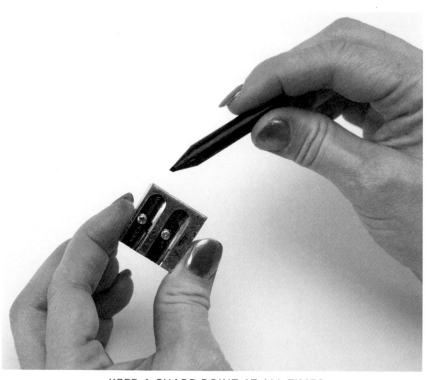

KEEP A SHARP POINT AT ALL TIMES
Use a tungsten steel hand-held sharpener. The blade stays sharp and keeps a good point on your crayons.

- *Pink Pearl or white vinyl erasers*: They can easily remove grid lines and unwanted lines from your drawing, and are good for large areas and general cleaning.

- *Union eraser*: This is actually two erasers in one, with one side a regular eraser and the other an ink eraser. The ink eraser is highly abrasive, so use it with care. While it is great for getting rid of tough marks, it can literally go right through the paper if used too hard.

Mechanical Pencil

I always create my initial line drawing with a mechanical pencil. It produces very light, consistent lines that are easily removed with a kneaded eraser.

Acetate Graphs

Acetate graphs are overlays to place over your reference photos. They have grid patterns over them that divide your picture into even increments, making it easier to draw accurately.

I use them in both 1-inch (25mm), and ½-inch (13mm) divisions. They are easy to make with a permanent marker on a piece of clear acetate. A report cover works very well, because it holds your photo reference in place. You can also draw the grid on a piece of white copy paper and have it made into a transparency on a copy machine. For your convenience, a tear-out acetate grid is included at the back of this book.

Color Finders

Use this homemade tool to identify and match the color in your drawing to the color in your reference photo.

Drafting Brushes

Crayons create a large amount of wax debris as you work that can stick to the paper and make unwanted marks. If you try to brush the debris away with your hand, you can create smudges that cannot be erased. A horsehair drafting brush gently swipes the debris away without smearing your work.

Masking Tape

This is also a good tool for getting the debris off of your paper. Take a loop of masking tape and gently tap it on your drawing as you work. It will lift off the stubborn flecks of color.

Craft Knife

A craft knife can be used as a drawing tool. The edge of the blade can gently scrape away color to create fine lines and texture such as hair or fur. A knife can also be used to gently remove unwanted specks that may appear as you work. Be careful with this technique so you don't gouge or damage your paper.

Reference Photos

For practice, collect reference photos from magazines. Tear out pictures of every subject and categorize them into different bins for easy reference. Don't try to replicate the photos, just use them for practice.

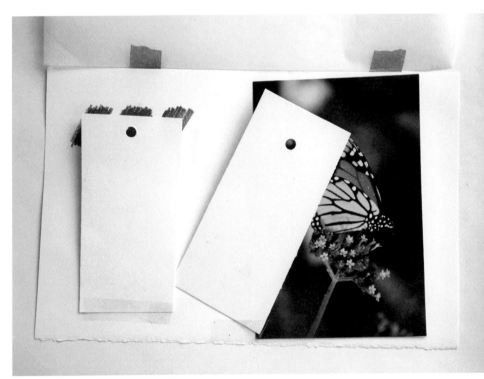

MATCH YOUR COLORS WITH A SIMPLE COLOR FINDER
Punch a hole into two white plain pieces of paper or index cards. Place one hole over your reference photo or image to help you focus on the color. Place the second hole over your artwork to help you match the color.

Techniques

chapter **two**

Lee's Lessons

When scratching, you produce a lot of crayon debris. Use a drafting brush to keep things clean, and use masking tape to lift off the stubborn flecks of color from your paper.

THERE ARE MANY DIFFERENT TECHNIQUES YOU WILL USE TO CREATE art with crayons. The three most used approaches are:

- **LAYERING**—Applying colors lightly, one on top of another, to give a gradual look of transitional color.
- **BURNISHING**—Applying color heavily with firm pressure, completely filling in the texture of the paper and making the color look smooth and shiny.
- **SCRATCHING**—Using the tip of a blade or craft knife to gently scratch out small light lines for texture.

Which technique to use depends on the subject you are attempting to capture and the texture you are trying to create. In most cases, you will use all the techniques in one drawing, combining them to create different looks. Before you begin to draw, analyze your subject matter and see what the surfaces look like. A smooth, even or shiny surface requires burnishing to make it look real. A textured or furry subject requires layering and/or scratching to make it look authentic.

LAYERING

Lightly apply Yellow to the paper first. Then, starting at the left and working toward the right, lightly layer Brick Red on top of the Yellow, lightening the touch as you go. Apply Scarlet next, overlapping the Brick Red, and lightening the touch moving right. Use Orange to soften the colors into the Yellow.

BURNISHING

The same four colors are used here, but firm pressure was applied to create burnishing. Again, Yellow was applied first, then Brick Red on the left with Scarlet overlapping that, and then Orange. Can you see how the wax content of the crayons creates a speckled appearance when heavily applied? This is the look of crayon. It is something to embrace, not avoid.

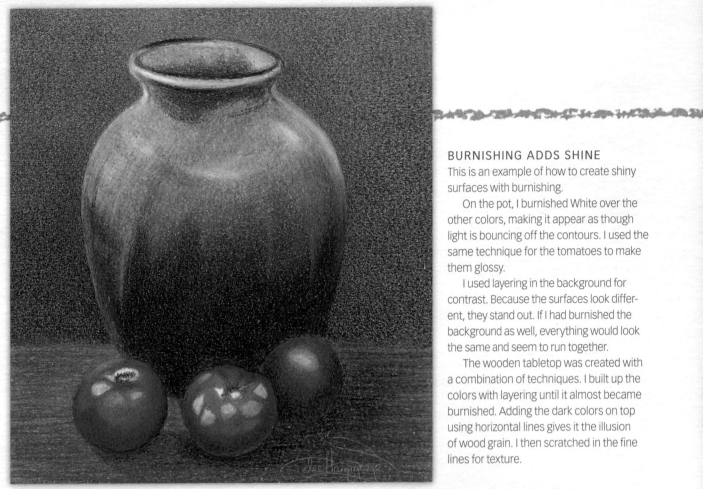

BURNISHING ADDS SHINE

This is an example of how to create shiny surfaces with burnishing.

On the pot, I burnished White over the other colors, making it appear as though light is bouncing off the contours. I used the same technique for the tomatoes to make them glossy.

I used layering in the background for contrast. Because the surfaces look different, they stand out. If I had burnished the background as well, everything would look the same and seem to run together.

The wooden tabletop was created with a combination of techniques. I built up the colors with layering until it almost became burnished. Adding the dark colors on top using horizontal lines gives it the illusion of wood grain. I then scratched in the fine lines for texture.

Crayon on Stonehenge paper, 10" × 11" (25cm × 28cm)

COLORS USED: (pot) Black, Fuzzy Wuzzy, Green, Peach, Sea Green; (tomatoes) Black, Maroon, Red, Sunset Orange, Yellow Orange; (wood table) Black, Brown, Burnt Orange, Chestnut, Fuzzy Wuzzy; (background) Black, Brown, Fuzzy Wuzzy, Maroon

LAYERING AND SCRATCHING CREATE TEXTURE

This drawing was done with both layering and scratching. Because of the bear's fuzziness, the fur was drawn with a flat tone of Yellow first and quick strokes of darker colors on top. The tip of a craft knife was used to gently scratch out the light little hairs.

The background was lightly layered to keep the colors soft and even, and to make them more subtle than the teddy bear.

Crayon on Stonehenge paper, 9" × 12" (23cm × 30cm)

COLORS USED: (teddy bear) Black, Brick Red, Brown, Goldenrod, Yellow Orange; (background) Aquamarine, Black, Blue, Brick Red, Sea Green

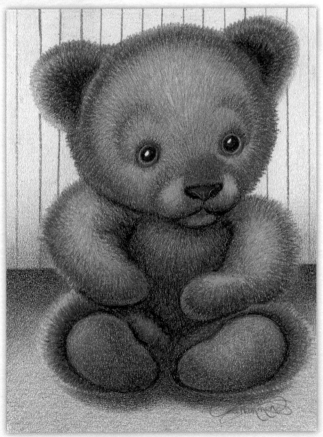

Practice Layering

Layering is the technique most commonly used with crayon. It is very important to apply the color smoothly and evenly, without the look of scribble lines. Follow these examples, and you will see what I mean. Keeping a sharp point on the crayon is essential to creating the controlled application.

MATERIALS

PAPER:
White Stonehenge

COLORS:
Black, Blue

OTHER:
pencil

1 SKETCH THE STONE

Lightly sketch in the shape of a stone with a pencil. Keep the pencil lines very light.

DO
This is what your color application should look like. Nice and smooth and even.

2 ADD COLOR

With a sharp Blue crayon, carefully apply the color evenly within the shape.

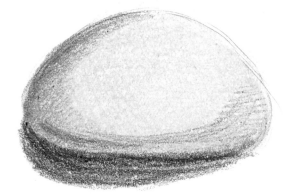

DON'T
This is what to avoid. Your color should not look choppy and scribbled.

3 DEEPEN THE TONE

With a sharp Black crayon, create the darker tones to make it look dimensional.

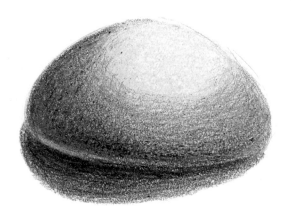

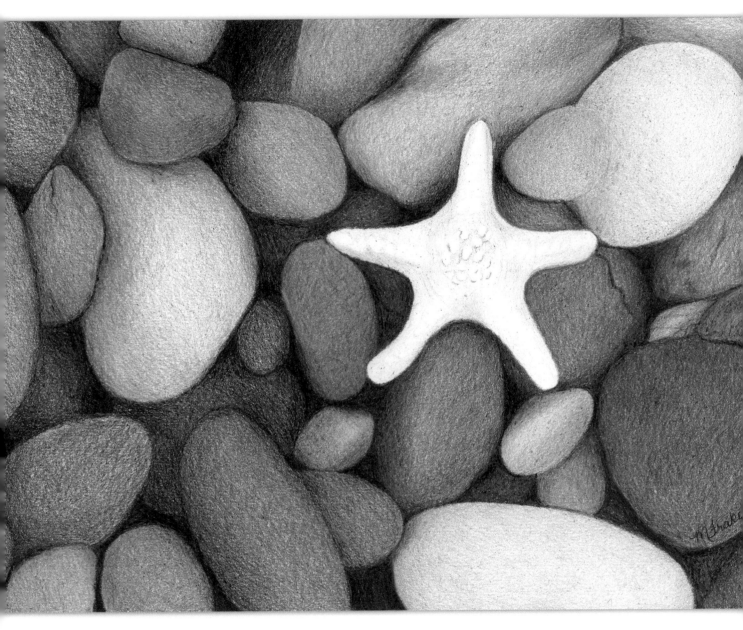

LAYERING REQUIRES PRACTICE AND PATIENCE
Layering was important in creating the surfaces of the stones. The color had to be applied evenly. Do not get discouraged if your first attempts look irregular and a bit choppy. The key is practice.

Stones and Starfish
Artist, Melissa Frakes
Crayon on Stonehenge paper, 12" × 16" (30cm × 41cm)

COLORS USED: Black, Blue, Blue Green, Cadet Blue, Cornflower, Midnight, Sky Blue

Burnishing and Scratching

These close-ups from the drawing of the betta fish show how both burnishing and scratching work to create color and texture.

It is not always necessary to make everything look hyperrealistic. Have fun when drawing with crayons, and let your creativity come through. The results can be striking, and they're fun to do.

By combining realism with abstract patterns and colors, wonderful things can be produced.

SCALES
To create the fish scales, I first applied the red colors with firm pressure until it was burnished. I then scratched out the patterns of the scales with a craft knife, revealing the lighter color underneath. The red crayons stained the paper, so when I scratched the red colors away, the pinkish stain showed below.

FINS AND GILLS
I used the scratching technique to create the transparent, ridged texture of the fins. Scratching out light lines gives you a much thinner line than you could ever draw. Combining scratching with drawing in darker lines creates the illusion of texture.

Notice the way the darker red (Maroon) behind the fins creates the shadow. I used a craft knife to scratch the ridges of the fin underneath, right through the shadows.

For the gill, I used a bit of Sky Blue first, and then added the red on top.

BACKGROUND
The patterns and flowing shapes of the seaweed in the background were exaggerated into less realistic patterns of color to contrast against the fish. Notice how the many different shades of green create these shapes. Black was used for the extremes.

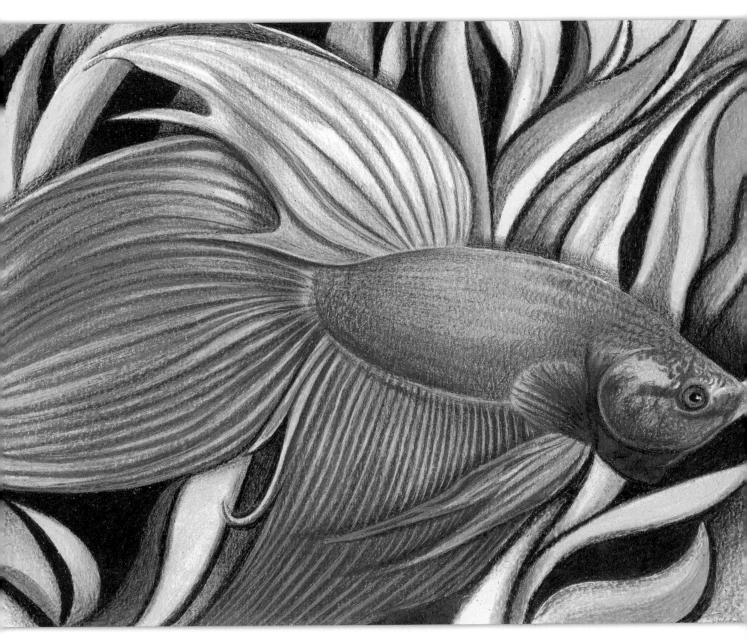

COMBINE TECHNIQUES TO CREATE CONTRAST

Crayon on 4-ply regular Bristol, 12" × 16" (30cm × 41cm)

COLORS USED: (fish) Carnation Pink, Goldenrod, Maroon, Red, Red Violet, Salmon, Violet; (background) Black, Fern, Green, Green Yellow, Inchworm, Olive Green, Pine Green, Sea Green

Lee's Lessons

If you have ever worked with colored pencil, then you have probably seen the haze that forms over the colors as the wax rises to the surface. You don't have to worry about that with crayon. Because crayons are made with a different type of wax, the wax and pigment don't separate. Therefore, it is not necessary to spray a fixative on your drawing when it is finished.

Visit www.artistsnetwork.com/newsletter_thanks for a free download of *The Artist's Magazine*.

21

Combining Techniques

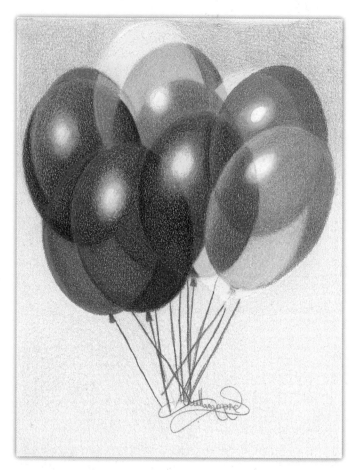

ACHIEVE A LOOK OF TRANSPARENCY

Burnishing everything solid would have made it difficult to transition the colors. By allowing a bit of the texture to come through, the transparency of the balloons is more obvious.

To give the balloons an appearance of shine, White was used in the highlight areas, overlapping into the color. It was also added around some of the edges to help with the look of the form.

Look at the shapes that are created where the balloons overlap. Each shape has a color all its own. Don't try to create all of the colors by overlapping one over another. You won't have as much control, and the colors will look less pure.

Study of Balloons
Crayon on Stonehenge paper, 9" × 12" (23cm × 30cm)

COLORS USED: Black, Blue, Blue Green, Blue Violet, Goldenrod, Orange, Navy, Plum, Red, Red Violet, Scarlet, Sky Blue, Vivid Violet, Yellow, Yellow Orange

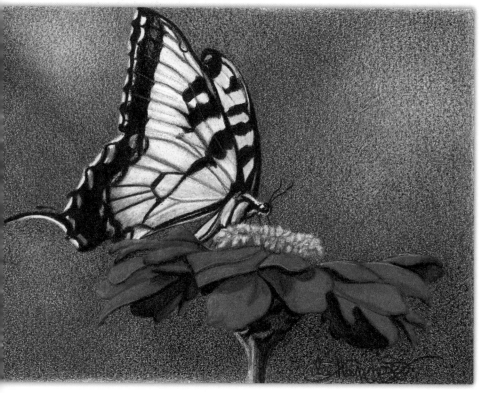

CREATE CONTRAST

This drawing combines heavy burnishing with multiple applications of layering. The two different techniques result in a beautiful contrast of color.

The boldness of the heavy burnishing in the butterfly and the flower creates deep, rich color. There is no crayon speckling due to the complete saturation of color.

Now look at the background. Because multiple layers of color were used, it remains grainy in appearance and all the colors are independent of one another. The more the colors are layered, the more speckling is produced.

Tiger Swallowtail
Crayon on Stonehenge paper
15" × 11" (38cm × 28cm)

COLORS USED: (butterfly) Black, Brown, Burnt Orange, Goldenrod, Laser Lemon, Red orange, Yellow; (flower) Black, Brick Red, Caribbean, Red, Scarlet, Yellow; (background) all of the above

Color Theory

The first thing you notice when you look at a piece of art is color. It can create a huge visual impact on the viewer.

With crayons, many people naturally tend to think of bright colors because that reflects their crayon experiences of childhood. But as an adult and an artist, you have the choice whether or not to make something bright and colorful, or simply monotone. Both approaches can bring about striking results. Before you begin, you must decide how you want your drawing to look.

Remember the drawing of the stones and starfish? Even though it is all in blue tones, it is gorgeous. A lot of color is not necessary to make a stunning drawing. Sometimes the hardest part of the drawing process is deciding how to approach the colors of your subject matter.

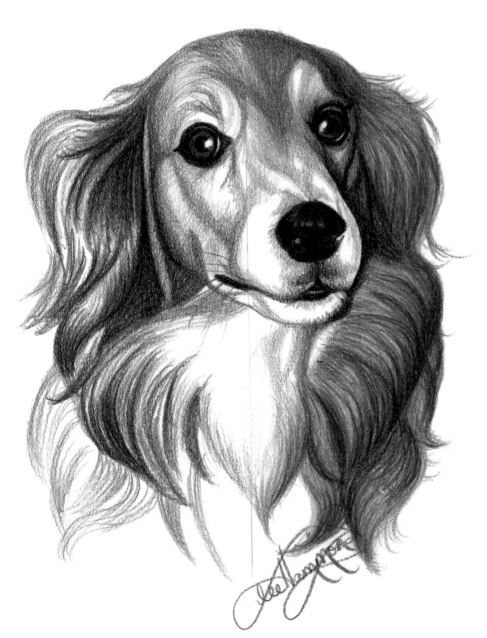

ONE SUBJECT, TWO TREATMENTS
This example shows how different one subject can look when done two different ways. Although the left side was done in only Black crayon, it looks good. If the entire drawing had been done this way, it would still look complete and professional.

Penny the Wonder Dog
Crayon on Stonehenge paper
11" × 14" (28cm × 36cm)

COLORS USED: Black, Brick Red, Brown, Goldenrod

Paint Animals With Lee

Watch a free video preview of *Painting Animals in Acrylic With Lee Hammond* at http://AmazingCrayon Drawing.artistsnetwork.com.

About Color

A good understanding of colors and how they work is essential. It all begins with the color wheel, which shows how colors relate to one another.

Primaries and Secondaries

There are three primary colors: red, yellow and blue. They are pure colors. Mixing these colors in different combinations creates all other colors. Mixing two primary colors makes a secondary color; for instance, red mixed with yellow makes orange. Secondary colors can be found in between the primary colors on the color wheel.

Warm and Cool Colors

The warm colors consist of yellow, yellow-orange, orange, red-orange, red and red-violet. The cool colors are violet, blue-violet, blue, blue-green, green and yellow-green.

Complementary Colors

Complementary colors are opposites on the color wheel; for example, red is opposite green. Complements can be used in many ways. Mixed together in equal amounts, complements become gray. For shadows, it is always better to mix a color with its complement than to add black.

A complementary color can also be used to make another color stand out; for instance, to make the color red stand out, place green next to it. This is used most frequently when working with flowers and nature. Because almost all stems and leaves are green and many flowers are red or pink, the flowers have a very natural way of standing out.

Shades and Tints

A shade is a darker version of a color. A tint, on the other hand, is a lighter version. Shades and tints are the result of light and shadow.

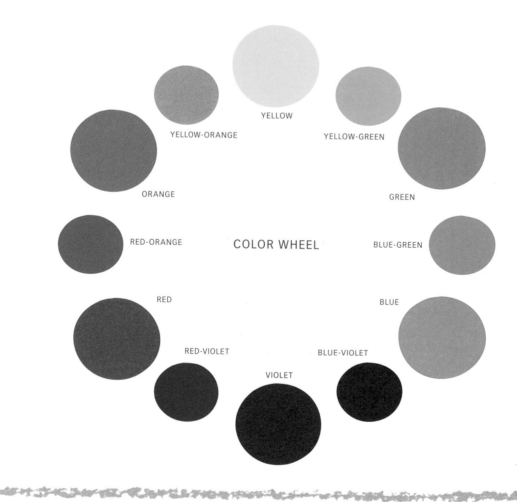

YELLOW

YELLOW-ORANGE

YELLOW-GREEN

ORANGE

GREEN

RED-ORANGE

COLOR WHEEL

BLUE-GREEN

RED

BLUE

RED-VIOLET

BLUE-VIOLET

VIOLET

Using Color

Color affects the way something appears. Artwork can be altered drastically simply by using different color combinations. Here is an example of how one subject can look different depending on the colors that surround it.

COMPLEMENTARY COLORS
Yellow vs. Violet

COMPLEMENTARY COLORS
Red vs. Green

COMPLEMENTARY COLORS
Blue vs. Orange

Visit www.artistsnetwork.com/newsletter_thanks for a free download of *The Artist's Magazine*.

25

Five Elements of Shading

In order to achieve realistic drawings, you must be able to draw three-dimensional forms and understand how light affects those forms. Five elements of shading can be found in every three-dimensional shape (demonstrated here with a sphere). Practice creating these different tones. Once you've mastered them, you can draw just about anything.

1 *Cast shadow*: This is the darkest part of your drawing. It is underneath the sphere, where no light can reach.

2 *Shadow edge*: This is where the sphere curves and the rounded surface moves away from the light.

3 *Halftone area*: This is the true color of the sphere, unaffected by either shadows or strong light.

4 *Reflected light*: This is the light edge along the rim of the sphere that illustrates the roundness of the surface.

5 *Full light*: This is where the light is hitting the sphere at its strongest point.

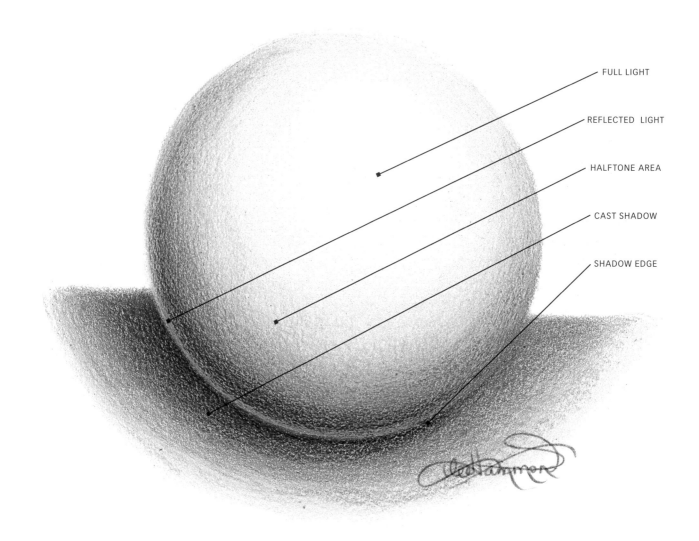

FULL LIGHT

REFLECTED LIGHT

HALFTONE AREA

CAST SHADOW

SHADOW EDGE

Basic Shapes

All subjects, no matter how complex, consist of underlying basic shapes. Learn to recognize these basic shapes, and you can draw anything by applying the five elements of shading.

CYLINDER
This shape (top left) is seen in arms, legs, trees and structures such as jars, glasses and cans.

LONG CYLINDER
This shape (top right) can be seen in tree limbs, pipes, columns and other tubular structures.

EGG
This shape (left) is seen in birds, animals and the human head.

CONE
This shape is seen in pointy objects such as party hats, building structures and vases.

FIVE ELEMENTS CREATE FORM
You can see how important the five elements are when looking at these oranges. Without them, the roundness and form would not be shown. It is the shading that makes them look three-dimensional.

Practice drawing the basic shapes, using the information seen in the sphere.

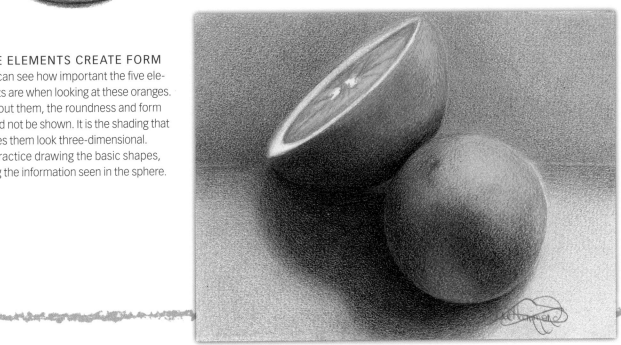

Visit www.artistsnetwork.com/newsletter_thanks for a free download of *The Artist's Magazine*.

27

Draw a Sphere in Black

Start with this exercise, using only a Black crayon. Keep a sharp point on your crayon as you work, so the tones look more refined and delicate. The more blunt your crayon becomes, the more speckled the tones will appear.

Take your time and try to make your sphere look as close to mine as possible.

MATERIALS

PAPER
White drawing paper

COLORS
Black

OTHER
pencil, ruler, template
or circular object for tracing

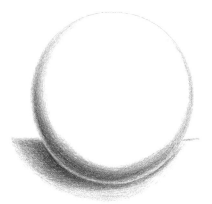

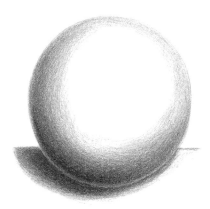

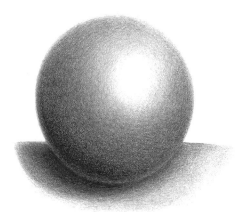

1 START THE SPHERE

To draw the sphere, use a template or trace around a circular object such as a drinking glass with a very light pencil line. Don't use the crayon because it will make too dark and thick a line. With a ruler, draw a light line for a table edge. Switch to black crayon. Beginning under the sphere, draw in the cast shadow. Do not burnish. Build the tone with layers. The shading is darkest directly underneath the sphere, and gets lighter as the shadow moves away. Move up into the sphere itself and place the shadow edge, lightening the shading as you move toward the center. Leave the outer edge of the sphere lighter to represent the reflected light. Keep the tip of your crayon sharp.

2 CONTINUE ADDING TONE AND CONTOUR

Continue adding tone, lightening your touch as the shading moves to the full light area. Curve your strokes to match the contours of the sphere. This creates the halftone. Add a bit more tone to the cast shadow below to make it darker.

3 FINISH WITH CURVED STROKES

Deepen all the tones to make the sphere and the cast shadow darker. Add some tone to the right side of the sphere to establish the look of the table edge. Go slow and keep a sharp point on your crayon. Turn your paper as you work to help with the curved strokes.

Draw a Sphere in Color

Now it is time to add the element of color to your sphere. This one was done using pink and red tones. While it is very similar to the one done in only black, color adds more complexity to the project.

MATERIALS

PAPER
White drawing paper

COLORS
Black, Brick Red, Carnation Pink

OTHER
pencil, ruler, template
or circular object for tracing

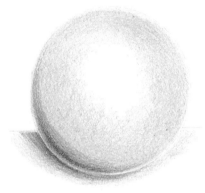

1 START THE SPHERE

Trace the circle on your drawing paper with a pencil. Add a light layer of Carnation Pink. Keep a sharp point on the crayon and be sure that the pink looks even. Allow an area of white to show to represent the full light area.

Draw in the cast shadow with Brick Red. Do not burnish. Build the tone with layers. The shading is darkest directly underneath the sphere and gets lighter as the shadow moves away.

Move into the sphere and place the shadow edge with Brick Red, getting lighter as you move toward the halftone area. Leave the outer edge of the sphere lighter to represent the reflected light. Keep the tip of your crayon sharp at all times.

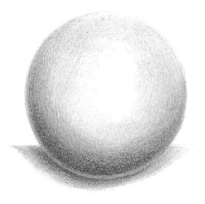

2 CONTINUE ADDING TONE AND CONTOUR

Continue adding tone to the sphere with Brick Red, lightening your touch as it moves to the full light area. Curve your strokes to match the contours of the sphere. Add a bit more tone to the cast shadow below to make it darker.

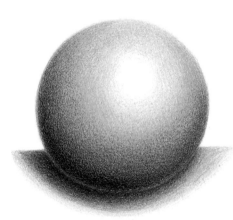

3 FINISH WITH CURVED STROKES

Deepen all the tones to make the sphere and the cast shadow look darker. Add some Black on top of the Brick Red to deepen the colors of the shadow areas. Go slow and keep a sharp point on your crayon. Turn your paper as you work to help with the curved strokes.

Visit www.artistsnetwork.com/newsletter_thanks for a free download of *The Artist's Magazine*.

29

Fun Spheres

Once you have mastered the sphere, it is a good idea to get even more practice. You can now morph the sphere into more recognizable and fun subject matter. These two examples show how the sphere is seen in many things. If you try, you can see the sphere in many everyday objects such as marbles and fruit. Remember that all the realism comes from the five elements of shading. Review them often, and commit those elements to memory.

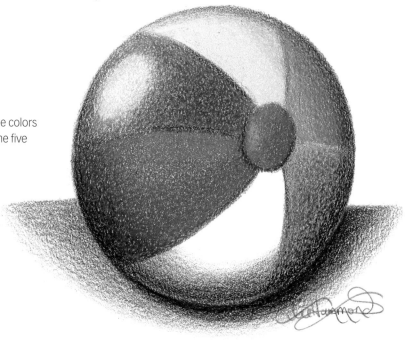

BEACH BALL
This beach ball is just a sphere incognito! While the colors are its most obvious trait, looking closer reveals the five elements of shading.

COLORS USED: Black, Blue, Green, Orange, Red, White, Yellow

SATURN
This representation of Saturn takes the sphere example even further. Although it is clearly not that realistic, it is fun and colorful. Such whimsical projects make learning to draw with crayons more fun. Sometimes practicing with something like this is less intimidating than something super realistic.

COLORS USED: Black, Blue, Brick Red, Laser Lemon, Orange, Outer Space, Red, Sea Green, Yellow

Draw a Heart

This is not a difficult project, but it is good practice for the things taught in the sphere exercises. While the change of shape alters the five elements of shading and the way they look, they are still crucial elements to making the heart look three-dimensional.

MATERIALS

PAPER
White drawing paper

COLORS
Black, Blue, Carnation Pink,
Maroon, Red

OTHER
Pencil

1 DRAW THE HEART
Using the example as a guide, carefully draw the shape of the heart with a light pencil line. Include the shadow on the right side and the highlight areas that are outlined within the heart shape.

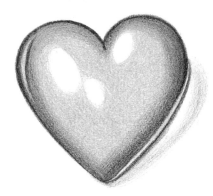

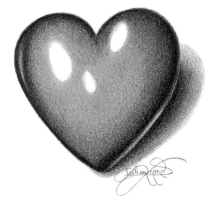

2 ADD COLOR AND SHADOW
With Carnation Pink, carefully fill in the heart shape with an even layer of color. Keep a nice point on your crayon. Add a little to the shadow area as well. Be careful NOT to go over the graphite lines in the highlight areas. When crayon goes over graphite, the line becomes very dark and impossible to cover with a light color. Do not worry about it too much in the shadow areas, for the darker color will cover it.

3 LAYER IN MORE COLOR
With Maroon, carefully outline the edge of the heart. Sharpen the crayon to a point again, and then slowly layer the color into the heart. Switch to Black, and add a small line of it along the lower edges of the heart shape. Add some to the shadow as well. Add a small amount of Blue to the shadow area as seen in the example.

4 ADD FINISHING TOUCHES
Deepen all the colors. Go back to Maroon and go over everything you did before to make it look richer. Use a Red crayon with a sharp point to transition the Maroon into the pink. Use Black with a sharp point to deepen the shadow edge on the right side of the heart. Carry the Black along the upper edge to help make the heart look dimensional. Add more Black to the cast shadow to make the reflective light stand out. With the Blue and Carnation Pink, add more color to the cast shadow so the colors transition together.

Visit www.artistsnetwork.com/newsletter_thanks for a free download of *The Artist's Magazine*.

31

The Grid Method

Everything you draw can be done more accurately if you look at your subject matter as a group of interlocking, abstract shapes. Placing a grid over your reference photos can help you see things more objectively by dividing everything into small sections. The squares help you see your subject matter like a puzzle. You can even further your objectivity by turning the photo upside down.

There are two different ways to grid your reference photos. The first way is to have a color copy made of your photo. If the photo is small, enlarge it. Working from small photos is the biggest mistake most students make. The bigger the photo, the easier it is to work from.

Use a ruler to apply a 1-inch (25mm) or ½-inch (13mm) grid directly onto the copy with a permanent marker. Use the smaller grid if there is a lot of detail in your photo. There is less room for error in the smaller box, so little things are captured more easily.

If you don't have access to a copier and your photo is large enough to work from, place a grid overlay on top of the photo. Make your own grid with a clear plastic report cover and a permanent marker, or have one printed from a computer on an acetate sheet.

Once you place the grid over the photo, the image becomes a puzzle and each box contains shapes. Look at everything you want to draw as a bunch of interlocking shapes.

Draw a grid on your drawing paper with a mechanical pencil.

Draw the lines so light you can barely see them. You will have to erase them later. This grid should contain the same size and number of boxes as the grid over the photo.

Enlarge the size of your drawing by placing the smaller grid on your reference photo and making the squares larger on your drawing paper. For instance, if you use the ½-inch (13mm) grid on the photo and a 1-inch (25mm) grid on your paper, the image will double in size. Reduce the size of the drawing by reversing the process. As long as you are working in perfect square increments, the shapes within the boxes will be relative.

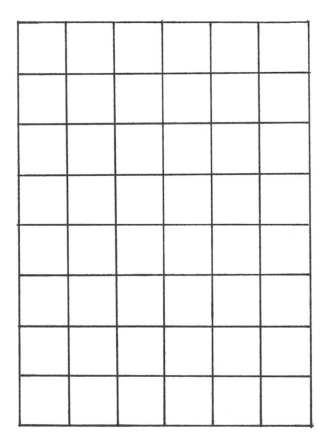

A ½-INCH (13 MM) GRID

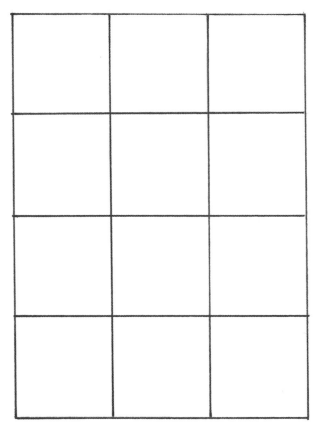

A 1-INCH (25 MM) GRID

Create a Line Drawing With a Grid

Placing a grid over a photograph helps you draw the shapes more accurately. For now, don't worry about the colors in the photo. Just concentrate on using the grid as a guide to capture the basic shapes in an accurate line drawing.

You can increase the size of your drawing by drawing larger squares on your paper.

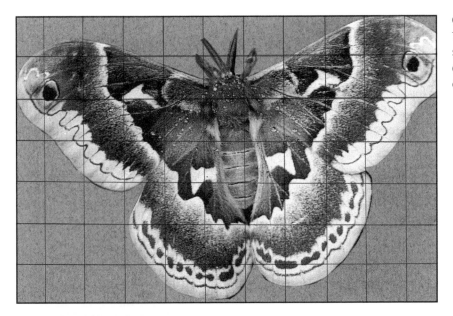

CREATE A GRID ON YOUR PAPER
The complex shape of this moth has been simplified by dividing it into boxes. Lightly draw a grid with the same number of boxes on your drawing paper.

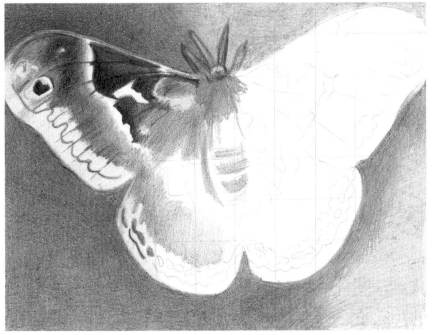

FILL IN THE SHAPES
Work on one box at a time, as you capture the shapes you see in each box. Go slowly and strive for accuracy. Carefully remove the grid lines from your paper as you go.

Lee's Lesson
You can also reduce the size of a drawing by making your boxes smaller on your drawing paper. However, the wax content of crayons naturally creates a wider line, so the bigger your drawing is, the more accurate you can be.

Visit www.artistsnetwork.com/newsletter_thanks for a free download of *The Artist's Magazine*.

33

Draw a Pear

Let's take everything we have learned so far and create a drawing of a pear. You can see how important the colors in the background are to creating the look of realism. Be sure to always maintain a sharp point on your crayons as you work to keep the layering delicate and even in tone.

Here are the things that this project will give you practice with:

- Using the grid method
- The five elements of shading
- Layering the color with a sharp point
- Burnishing for deep, rich color (the stem)
- Complementary colors from the color wheel (yellow vs. violet)

MATERIALS

PAPER
White Stonehenge

COLORS
Eggplant, Fuzzy Wuzzy,
Mauvelous, Scarlet,
Violet, Yellow

OTHER
black colored pencil,
kneaded eraser,
mechanical pencil, ruler

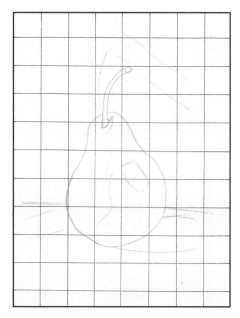

1 CREATE THE LINE DRAWING

With a mechanical pencil, very lightly draw a 1-inch (25mm) grid on your drawing paper. Draw the shape of the pear by drawing the shapes you see within each square, going one box at a time. This is the time to be very accurate. Make any changes you need to before you start applying the color. When you are happy with the shapes, carefully remove the grid lines with a kneaded eraser.

2 ADD COLOR

Carefully lighten the pencil lines with a kneaded eraser. Then, with Yellow, fill in the majority of the pear. Also apply Yellow lightly onto the tabletop around it, and into the entire background area. To create the light edge on the left side of the pear, apply Mauvelous into the background. Add some Mauvelous into the cast shadows on the tabletop as well. With Scarlet, create the shadow edge going down the center of the pear. This forms the three-dimensional curve.

3 BUILD COLOR AND SHADOW

Build the layers of color to continue the illusion of form. To deepen the color of the shadow edge, apply a small amount of Violet. Add Violet to the right side of the pear and to the cast shadow as well. Add more Mauvelous to the background to create the shadow patterns on the wall. Then layer Eggplant over it to deepen the colors.

4 FINISH AND FRAME

To finish the pear, deepen the brownish tones on the right side. Use Fuzzy Wuzzy and Eggplant. Continue adding the tones in the background; your goal is to make the colors even and smooth. When you are happy with the colors, tones, and evenness of the colors, complete the piece by drawing a border box around the edges with a ruler. The border acts as a natural framework. Use a black colored pencil and deepen the lines of the border box. I used the colored pencil to sign my name too, because a crayon makes such a wide line, and this is such a small drawing.

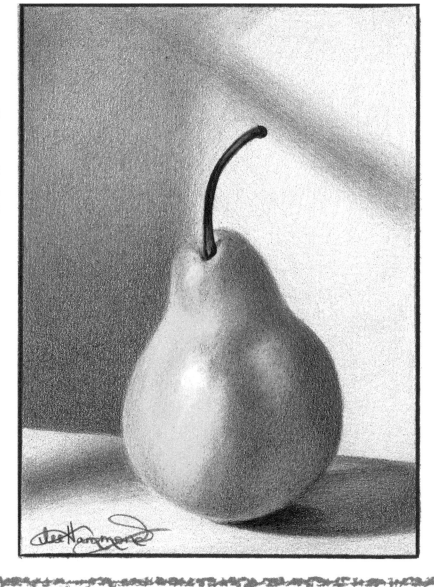

Visit www.artistsnetwork.com/newsletter_thanks for a free download of *The Artist's Magazine*.

35

Lee's Lessons

When layering many different colors, do not be overly concerned with a strict procedure. The end result can be achieved using a variety of colors, and the order that the colors are applied is not that important. Start with the light ones, and build up from there.

SOME HAVE SAID I PLACE WAY TOO MUCH EMPHASIS ON THE SPHERE, but I disagree. I cannot argue strongly enough the importance of it, and what valuable skills are gained from repeatedly practicing the sphere exercises.

Art students will always do better if they stick with drawing spheres until they are accomplished at it. This commits the five elements to memory and makes them second nature to you as you draw. Someone who skips over the sphere part of the book will usually go on to produce drawings that lack dimension and look outlined and flat.

LAYER FOR SIMPLE SHAPES

This is a good example of the type of art you can create once you have mastered different techniques. The round shapes are simple enough that the grid method is not necessary for drawing it. But the colors are not as simple. It takes many layers of gently applied color to make crayon look this soft and subtle.

Practice drawing this yourself. Remember to have a sharp point on your crayon, and apply very light layers of color over one another.

Study of Yellow Apples
Crayon on #1008 Ivory mat board
10" × 12" (25cm × 30cm)

COLORS USED: Black, Maroon, Orange, Yellow, Yellow Green

chapter three
Round Objects

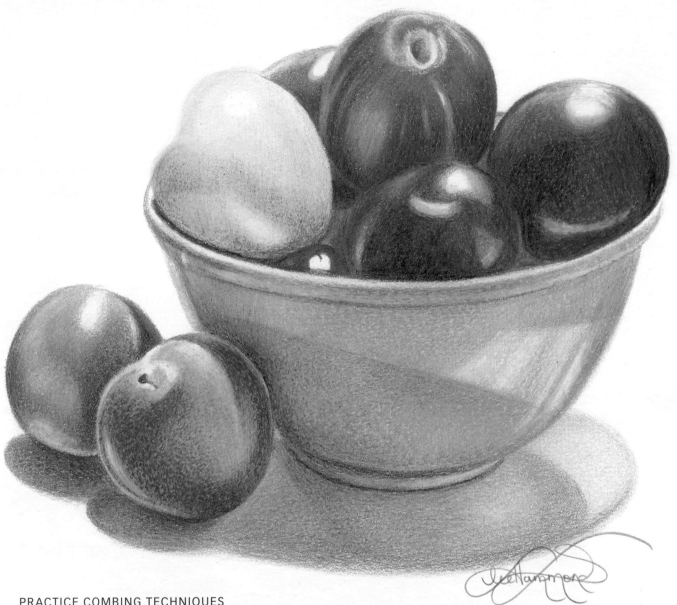

PRACTICE COMBING TECHNIQUES

This is another great example of the sphere. It clearly shows the benefits of drawing fruit when learning techniques and the five elements of shading.

Study of Plums
Crayon on Stonehenge paper, 11"× 14" (28cm × 36cm)

COLORS USED: (green plums) Laser Lemon, Spring Green, Yellow Green; (yellow plums) Brick Red, Brown, Mahogany, Melon, Peach, Red Orange; (red plums) Red, Scarlet, Vivid Violet; (purple plums) Blue Violet, Outer Space, Plum, Violet Red; (bowl and cast shadow) Black, Brick Red, Brown, Cornflower, Melon, Peach, Vivid Violet, Yellow Green

Lee's Lessons

Use White to burnish colors together and make them look smoother. Use it in highlight areas to make objects look shiny.

Draw Burnished Plums

To practice burnishing with crayons, follow step by step to create plums in a variety of colors.

MATERIALS

PAPER
White Stonehenge

COLORS
Apricot, Black, Blue Violet,
Carnation Pink, Green, Green Yellow,
Mauvelous, Plum, Red Violet,
White, Yellow Orange

OTHER
kneaded eraser, pencil

Green Plum

1 SKETCH THE PLUM
Lightly sketch the shape of the plum with a pencil. Fill in the entire plum with a solid layer of Green Yellow. Start applying the shadow edge along the left side of the plum with Green.

2 ADD FORM AND SHADOW
Continue applying Green to create the roundness and form of the plum as shown. It closely resembles the sphere exercise. Add a small amount of Black under the plum for a cast shadow.

3 DEEPEN THE COLORS
With firmer pressure, keep applying Green to deepen the color. Add Blue Violet to the shadow areas to deepen the color and develop the roundness. Add a small amount of Black to the shadow edges as well. Burnish some White into the highlight areas, and use Black to create the stem.

To finish the cast shadow, add all of the colors used on the plum into it. Apply them in the same order, from light to dark, ending with deep Black where it is closest to the plum.

Red Plum

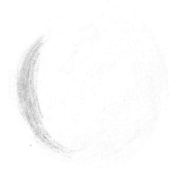

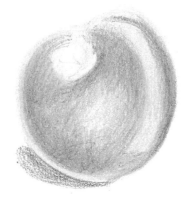

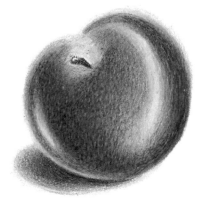

1 SKETCH THE PLUM
This red plum has a light orange undertone to it, so base in the entire plum with a layer of Apricot. To start the shadow edge, apply Yellow Orange as shown.

2 ADD FORM AND SHADOW
Add more Yellow Orange to deepen the colors. Use Mauvelous to add more color to the shadow edges to help develop the look of roundness. Add a small amount of Black to the cast shadow underneath the plum.

3 DEEPEN THE COLOR
Create the deep reddish color of the plum by adding the color Plum with firm pressure. Add this color to the shadow edges and down into the cast shadow. Add some Yellow Orange into the outer edge of the cast shadow as well.

To deepen the colors of the plum, add Red Violet in the darkest areas. Add White in the highlight areas to make it look shiny. Use Black for the stem.

Purple Plum

Create the purple plum using the same procedure as the other plums. As you can see, this one is much deeper in color. Changing colors will give you practice with the individual color's characteristics. Use firm pressure to make the colors rich.

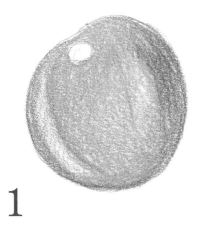

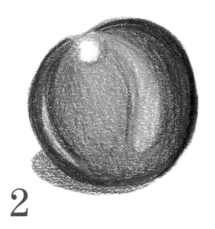

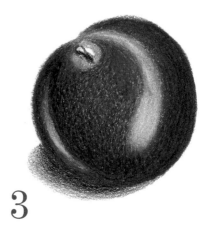

1

2

3

Visit www.artistsnetwork.com/newsletter_thanks for a free download of *The Artist's Magazine*.

39

Draw a Teapot

This exercise has many of the elements seen in the pear exercise. The teapot requires the same light layering of color, and the same approach used to draw the pair background is applied here.

MATERIALS

PAPER
White Stonehenge

COLORS
Black, Blue Green, Canary, Carnation Pink, Green, Green Yellow, Mauvelous, Plum, Sky Blue, Spring Green, Yellow Orange

OTHER
kneaded eraser, pencil, ruler

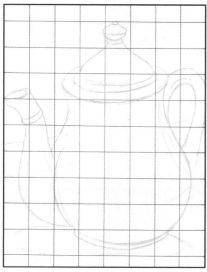

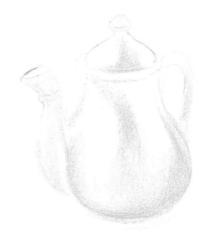

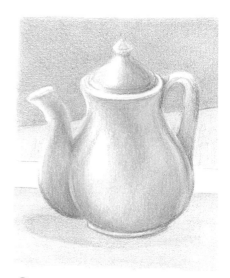

1 CREATE THE LINE DRAWING

Use the graphed example here to draw the shapes of the teapot. Lightly draw a grid of 1-inch (25mm) squares on your drawing paper. When you are happy with the accuracy of your drawing, carefully remove the grid lines from your paper with a kneaded eraser.

2 LAYER IN COLOR

Start with the lightest color, called the "undertone." This is the color seen peeking through all the other colors. In this case, the undertone is yellow. With a sharp point on your crayon, lightly apply Canary to the pot, leaving the white of the paper for the highlight.

Layer Carnation Pink over the Canary to start the five elements of shading. Add it to the shadow edges as well.

3 ADD THE BACKGROUND

With a ruler, lightly draw the border box and the lines in the background. Fill in the entire upper background and the cast shadow underneath the pot with Green. Fill in the rest of the background, except for the strip behind the pot, with Spring Green. Apply a small amount of Yellow Orange on top of the Spring Green along the edges of the background and the bottom of the tabletop. Then layer Sky Blue down the right side of the pot. Add some to the lid, handle and spout as well. Switch to Plum, and continue developing the shape of the pot. Keep the color application light, so all the colors show through.

Learn more at http://AmazingCrayonDrawing.artistsnetwork.com.

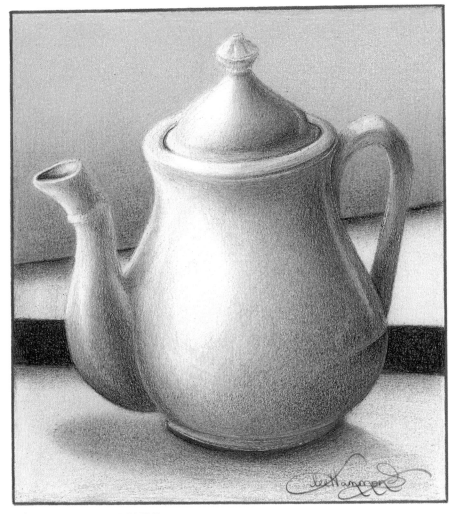

Lee's Lessons

Burnishing with crayon can be a bit frustrating because the wax is so heavy. Often, if using a lot of pressure, the color will actually move or flake off. If the wax builds up too much, you can remove some of it with a craft knife, and then reapply. Once the initial layer of color is burnished heavily, the remaining colors should be added with less pressure.

4 FINISH THE DETAILS

Add Mauvelous to the teapot to build the purplish tones, layering it into the areas of shadow along the lower portions of the lid, handle, pot and spout. Also add Mauvelous to the cast shadow region below the teapot.

Use a light application of Black to fully develop the illusion of form. This requires a very light touch and a sharp point on the crayon at all times. Add a deeper application of Black underneath the teapot to create a crisp edge where it meets the table surface. Then soften the edge gradually into the shadow area so it doesn't look like an outline.

To deepen the background color, apply Blue Green to the lower portion where it meets the countertop, gradually lightening as it moves up. Add Green Yellow starting at the top and working down to lighten the upper portion.

Add another crisp line of Black to the background to give the illusion of two surfaces coming together. Again, gradually soften the outline appearance to make it appear as a soft shadow.

Visit www.artistsnetwork.com/newsletter_thanks for a free download of *The Artist's Magazine*.

41

Everyday Cylinders

Cylinders and ellipses are found in many ordinary, everyday objects and are often seen together with other shapes.

SPHERE AND CYLINDER TOGETHER

The ice cream cone (right) is a combination of the sphere on top and the cylinder below. You could also change the shape of the cone to an actual cone shape and practice drawing it that way.

I love the shape of the bottle (below), with the cylinder on the top and the sphere on the bottom. The deep green tones make this drawing beautiful, even without a background.

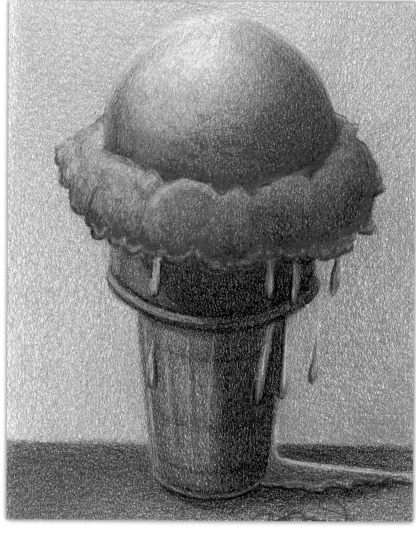

Drawing of an Ice Cream Cone
Crayon on Stonehenge paper, 10" × 8" (25cm × 20cm)

COLORS USED: (ice cream) Apricot, Carnation Pink, Magenta, Maroon, Melon, Red Violet; (cone) Black, Brick Red, Brown, Magenta, Maroon, Tan; (background) Apricot, Melon, Salmon; (table) Black, Melon, Plum

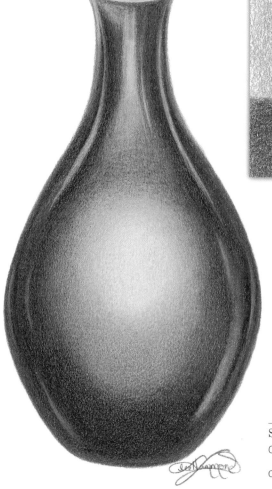

Study of a Green Bottle
Crayon on Stonehenge paper, 14" × 11" (36cm × 28cm)

COLORS USED: Black, Blue Green, Granny Smith Apple, Green, Green Yellow, Indigo, Yellow Green

Draw Cylinders

You've had plenty of practice with the sphere, so let's mix it up now and practice drawing other shapes. Follow along to draw a small branch and leaf, and a tree trunk.

DEMONSTRATION

MATERIALS

PAPER
White Stonehenge

COLORS
Black, Brown, Chestnut,
Green, Peach

OTHER
craft knife, pencil

Draw Branches

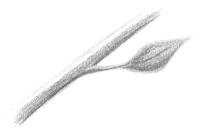 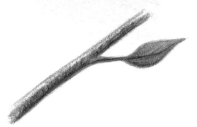

1 SKETCH THE LIMB AND LEAF
With a pencil, lightly sketch the shape of the limb and a leaf. With Black and a very sharp point, lightly add a small amount of tone along the bottom portion of the limb.

2 ADD COLOR
With Brown and a very sharp point, lightly add some color along the top edge and over the Black on the lower portion. Leave a strip of white paper exposed for the highlight area. Fill in the entire leaf with Green. Add a small amount of Black to the leaf.

3 DEEPEN TONE AND TEXTURE
With Black and firmer pressure, deepen the tones on the bottom portion of the limb. Deepen the Brown to make it more noticeable. With Black, create the curved lines that represent the texture of the branch. Add a bit more Black to the leaf to make it look more realistic.

Draw Tree Trunks

1 SKETCH THE TREE TRUNK
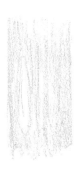
Lightly draw a cylinder with a pencil. Start with the lightest color; apply Peach to the tree trunk. Use irregular vertical strokes to begin the texture of the tree bark.

2 ADD COLOR
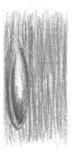
Add Chestnut over the Peach in the same way, with irregular vertical strokes. Use Brown to create the knot hole and to add more vertical strokes.

3 DEEPEN THE TONE AND TEXTURE

Continue adding vertical strokes with Black for texture. Add Black into the knothole for a shadow effect. Add more Brown to the center of the knothole. To further the look of tree bark, gently scrape some lines out of the colors in the trunk with a craft knife. This exaggerates the look of texture by highlighting the edges of the raised areas, making the darker areas look recessed.

Visit www.artistsnetwork.com/newsletter_thanks for a free download of *The Artist's Magazine*.

43

Ellipses

What happens when round objects no longer look perfectly round? When you look at a cylinder, from the top, the end looks like a circle. But when the cylinder is viewed from the side, the end appears as a circle in perspective. This perspective represents distance and changes a circle into an ellipse.

Receding lines are made shorter than they are in reality to create the illusion of depth. This is a phenomenon called foreshortening. It is what turns a circle into an ellipse.

STANDARD CIRCLE

VERTICAL ELLIPSE

HORIZONTAL ELLIPSE

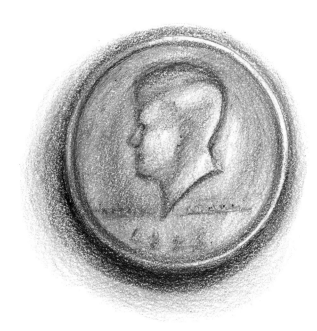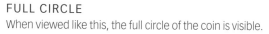

FULL CIRCLE
When viewed like this, the full circle of the coin is visible.

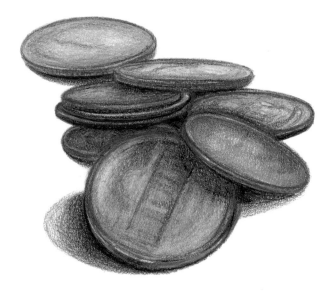

ELLIPSES
When coins are viewed like this, they become ellipses. The amount of the surface seen on each coin is different, depending on how much it is tilted toward the viewer.

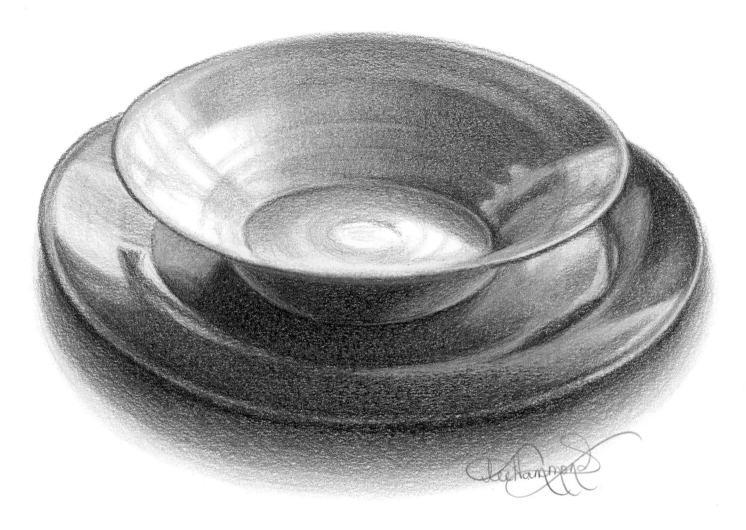

ELLIPSES SHOW PERSPECTIVE

This is a great example of the power of ellipses, and the way they produce perspective in what you are drawing. If you were to look straight down, the bowl and the plate would be perfect circles. However, the circles become distorted when you view them from the side. This angle makes them appear as horizontal ellipses.

Study of a Place Setting

Crayon on Stonehenge paper, 11" × 14" (28cm × 36cm)

COLORS USED: Black, Blue, Mauvelous, Melon, Peach, Purple Mountain's Majesty, Wisteria,

Lee's Lessons

When drawing elliptical objects, you should be able to fold each ellipse in half in either direction, with all parts matching. This is called the equal quarters rule.

Visit www.artistsnetwork.com/newsletter_thanks for a free download of *The Artist's Magazine*.

45

Drawing Through

There is a mathematical way to produce an ellipse based on the degree of pitch and its angles. But you don't need a formula to tell you when an ellipse is off.

Draw through the shapes as though they were transparent to make sure you have the correct perspective. For instance, draw the ellipses on both sides of a cylinder to get the curves correct. You can cover your lines later, when you add color. Drawing through will help you visualize your shapes.

When drawing any object, accuracy from the beginning is essential. It allows you the freedom of blending and shading without having to make structural changes. Altering the shape is very difficult after the tones have been added.

I have seen many drawings that were skillfully rendered fall apart visually because the perspective was off, causing the objects to look misshapen and skewed.

Remember that if it looks off, it usually is. The eye is a great judge. Even if you do not know immediately what is off, trust your eye.

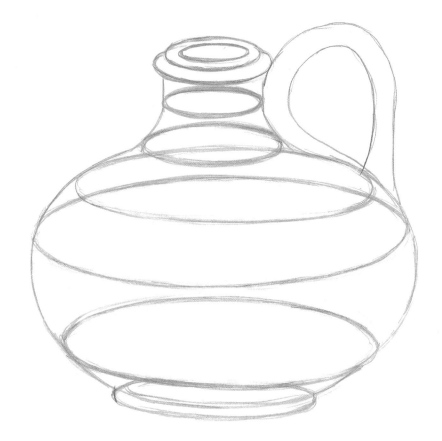

OUTLINE THE ELLIPSES
Sketch the jug's basic shape with a mechanical pencil. The ellipses encompass the surface of the jug, all the way around. Drawing through the object to complete the ellipses helps the jug look symmetrical and realistic.

Lee's Lessons

When an ellipse is drawn incorrectly, your brain screams that something is wrong. Here are three tips to drawing ellipses correctly:

- Remember, you are drawing a circular shape. There should be no flat spots or pointy areas in the smallest area where the ellipse curves.

- Visualize all sides of the elliptical object and draw the complete ellipse before shading. Try to see through it.

- You should be able to fold your ellipse in half, with all sides matching.

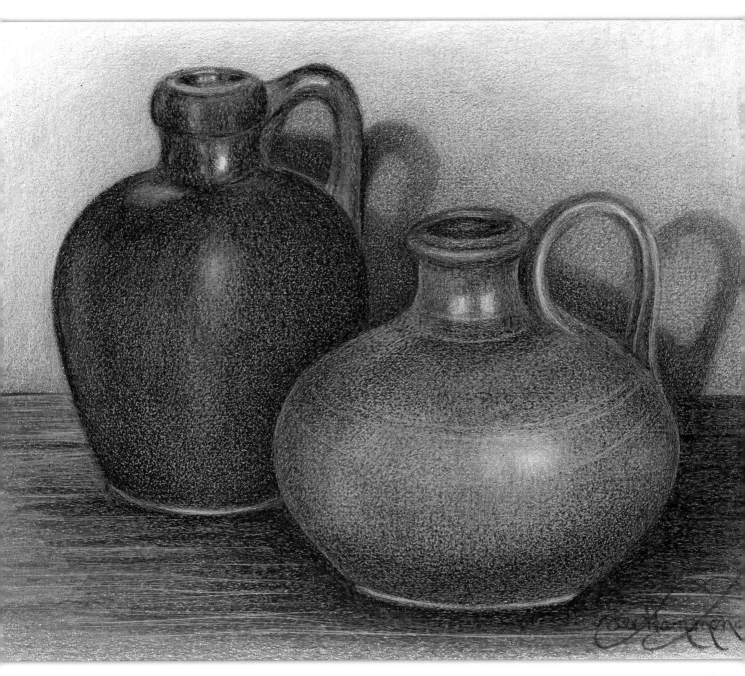

PERSPECTIVE IS KEY WITH ELLIPSES

Compare this drawing of crockery jugs to the see-through line drawing. You can see how important perspective is when you add the element of ellipses to your drawings.

Study of Crockery
Crayon on Stonehenge paper, 11" × 14" (28cm × 36cm)

COLORS USED: (crocks) Black, Brick Red, Brown, Burnt Orange, Peach, Sea Green; (background and wood table) Banana Mania, Black, Brick Red, Burnt Orange

Visit www.artistsnetwork.com/newsletter_thanks for a free download of *The Artist's Magazine*.

47

chapter four
Textures

ONCE YOU HAVE MASTERED THE PROCESS OF CREATING FORM AND accurately drawing shapes, it is time to learn how to create the illusion of various textures. This opens the door wide to creativity; the ability to form lifelike textures allows you to draw just about anything. As with anything else, starting slow is best.

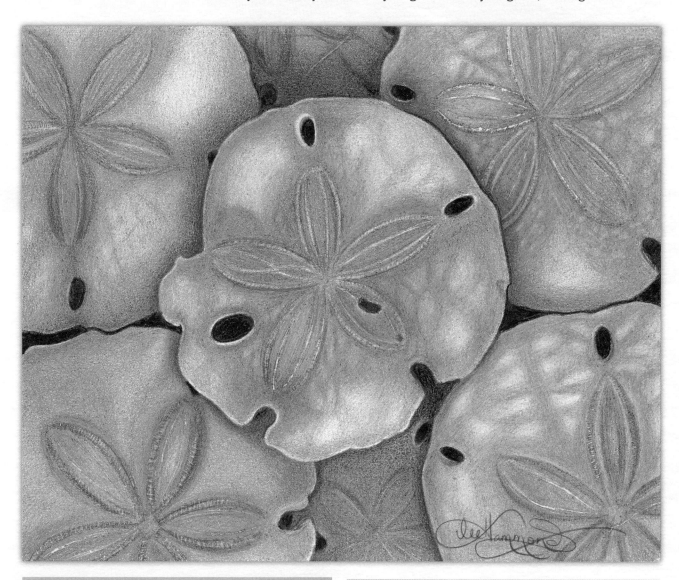

A Wealth of Sand Dollars
Crayon on Stonehenge paper, 11" × 14" (28cm × 36cm)

COLORS USED: Black, Bittersweet, Brick Red, Brown, Burnt Orange, Chestnut, Goldenrod, Mauvelous, Periwinkle, Plum, Yellow

Desktop Wallpaper

Download free wallpaper of this and other images at http://AmazingCrayonDrawing.artistsnetwork.com.

Draw Sand Dollars

Practice drawing a single sand dollar. That way it will not be so overwhelming. If you feel accomplished, you can do the whole drawing later on. Use the grid method to accurately draw the shape and surface pattern.

This exercise will give you more practice with the process of layering. In the drawing of the sand dollars, you can see that their texture is smooth, but not slick or shiny. They are extremely porous, with multiple colors on top of one another. This is a perfect project for layering.

DEMONSTRATION

MATERIALS

PAPER
White Stonehenge

COLORS
Black, Chestnut, Goldenrod,
Mauvelous

OTHER
craft knife, kneaded eraser,
pencil, ruler

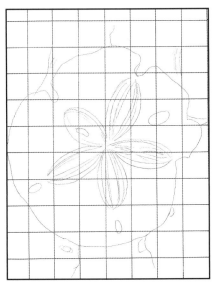

1 SKETCH THE SAND DOLLAR
Use the grid method to capture the shapes and patterns of a sand dollar.

2 ADD THE FIRST LAYER
Fill in the entire area of the sand dollar with a light layer of Goldenrod.

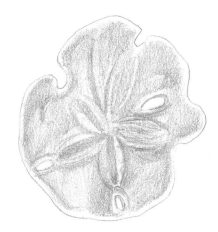

3 CONTINUE ADDING COLOR
Add some Chestnut and Mauvelous to create the brownish patterns. Chestnut has more orange in it. Mauvelous has more of a pinkish hue.

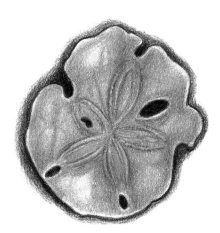

4 ADD SHADOW & DETAIL
Use Black and a light touch to create the flower pattern in the center. To add more interest to the center, use a craft knife to gently scrape some texture into it. Study the larger example on the previous page. Add Black around the edges and allow it to fade out like a shadow. Notice how the light edges are now standing out due to reflected light along the edges.

Draw a Conch Shell

A conch shell is a fun subject to draw because of its variety of surface textures. The inside of the shell is extremely shiny and smooth, while the outer surface is made up of ridges, edges, and protrusions.

MATERIALS

PAPER
White Stonehenge

COLORS
Blue, Brown, Caribbean Green, Carnation Pink, Hot Magenta, Inchworm, Mango Tango, Periwinkle, Sea Green, Shadow, Yellow

OTHER
kneaded eraser, pencil, ruler

1 SKETCH THE CONCH SHELL
Use the grid method to accurately draw all the small shapes you see in this conch shell. Use a 1-inch (25mm) graph or larger. Do not erase the grid from your paper until you are happy with your accuracy. Carefully remove the grid with a kneaded eraser.

2 ADD COLOR
Apply Yellow to the inside and outside of the shell, and Sea Green to the upper background. Add some Sea Green to the shell, too. You can see it above the Yellow and along the bottom of the pointy part on the left. Apply some Mango Tango to the upper left portion of the shell.

3 DEEPEN THE TONE AND CREATE TEXTURE
Place Carnation Pink along the inside edge. Apply it to the left leg of the shell and along the upper edge of the shell, leaving a small rim of white still showing. Below the pink, add a small amount of Periwinkle. This cool color starts the look of the curve.

Use Mango Tango to add orange tones. Apply it as smoothly as possible to the inside of the shell, and use it to create the textured ridges on the outside.

Add Inchworm to the background and the bottom foreground. Add Sea Green to the foreground as well, going over the Inchworm.

Place Carnation Pink underneath the shell. Color is reflective, so the pink of the shell is bouncing down.

Add some Periwinkle directly beneath the shell, to start the look of a shadow.

Learn more at http://AmazingCrayonDrawing.artistsnetwork.com.

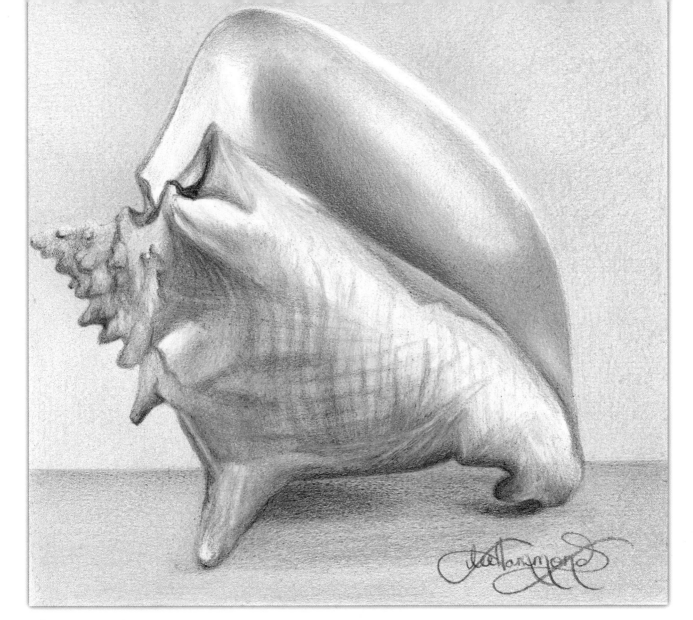

4 FINSH THE SHELL

To finish, all the colors must be smoothed out to look even. Start with the background and continue to layer Sea Green on the left until it looks even. Continue down over the Inchworm. Complete the background on the right with Caribbean Green. It is similar to Sea Green, but a bit bluer.

Build the colors of the foreground tabletop. Continue adding layers of the same colors from step 3, until the green tones are more even.

With Blue, apply a cast shadow directly underneath the shell. Apply some Blue to the edge of the tabletop and allow it to fade downward. With Shadow, lightly go over the cast shadow to make it deeper in tone.

To finish the shell, build the rich pink hues by adding Hot Magenta to the inner edge. Allow it to fade into the Mango Tango. Add more Carnation Pink and Mango Tango until it looks bright and smooth. Add a tiny bit of Sea Green inside the shell on the left side.

Finish the outside of the shell by deepening the colors and building more texture. The ridges of the shell need to be deepened with Mango Tango and Brown. Use more deliberate lines to create the look of the ridges. With Shadow, add all of the dark shadow tones to the underneath areas of the shell. (This is a great color for shadows, because it is dark, yet transparent, and only darkens the color it is placed over. It is not as overpowering as Black.)

Create the cast shadow along the upper edge of the shell. This is the back of the shell reflecting down.

Study all of the subtle colors of this project, and see how many you can see hiding. For instance, look at the left side of the shell and you will see tiny hints of blue and green peeking out of the bony protuberances. This small amount of color can do a lot to enhance the look of a drawing.

Visit www.artistsnetwork.com/newsletter_thanks for a free download of *The Artist's Magazine*.

51

Wood Grain

Drawing the look of wood grain is not nearly as difficult as it may seem. Built up in multiple layers, the wood grain itself is created by drawing noticeable lines and patterns with color. To further enhance the illusion of texture, you can use a craft knife to scratch out delicate lines. Doing so provides an even more realistic look.

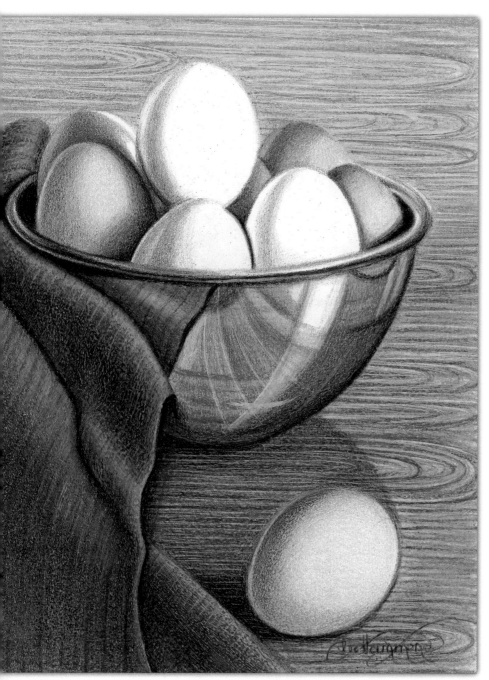

WOOD GRAIN CAN ENHANCE A DRAWING
This example shows how pretty the look of wood can be in a drawing. This still life would not be nearly as interesting without the addition of the wooden tabletop below, which creates a beautiful reflection in the metal bowl.

Still Life of a Bowl of Eggs
Crayon on Stonehenge paper
14" × 11" (36cm × 28cm)

COLORS USED: (tabletop) Black, Bittersweet, Brown, Burnt Orange, Goldenrod; (brown eggs) Black, Brown, Chestnut, Peach; (white eggs) Black, Blue, Eggplant, Red Violet; (towel) Black, Blue, Indigo, Red Violet

Draw Wood Grain

Drawing wood grain is fun and can add a lot of character to your artwork. It is not as difficult as it may look. Practice these techniques to master the look of wood grain.

MATERIALS

PAPER
White Stonehenge

COLORS
Bittersweet, Brown,
Chestnut, Goldenrod

OTHER
craft knife

1 SKETCH THE PATTERNS
Start with a heavy application of Goldenrod. With Bittersweet and a sharp point, add the oval patterns and straight lines of the wood grain.

2 DEEPEN THE COLOR
Add some Chestnut and Brown to deepen the colors, following the same patterns.

3 ADD DETAIL
With a craft knife, gently scratch out tiny lines following the same patterns.

Bricks

Bricks provide an interesting background pattern for a drawing because each brick is totally different from the next. No two are exactly alike.

When including bricks in your drawing, it is important to draw them accurately and in perspective.

Without the proper angles and vantage point, the bricks could throw the whole drawing off.

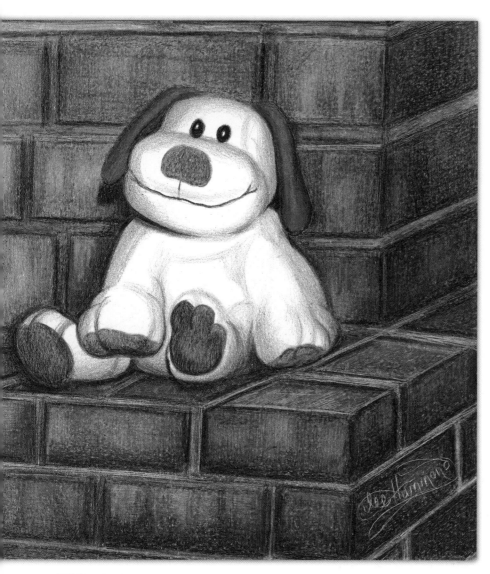

Plush Dog and Bricks
Crayon on Stonehenge paper, 14" × 11" (36cm × 28cm)

COLORS USED: (plush dog) Black, Green, Peach, Red, Shadow;
(bricks) Black, Brick Red, Brown, Chestnut, Gray, Shadow, Tan, White

MAKE A SIMPLE DRAWING MORE INTERESTING
This drawing was based on a photo I took. The plush dog always makes me smile, and the bricks behind it make for a delightfully colorful drawing. I love the look of bricks; the patterns they create can turn a simple drawing into an interesting piece.

Lee's Lesson's
Art should be personal, and the subject should be something that communicates with you. If it makes you feel good when you look at it, what could be better or more meaningful?

Draw Bricks

Some bricks are light in color, and others are deeply pigmented. Some are smooth, and some are chipped and textured. When drawing them, be sure not to become repetitive and draw all of them exactly the same way.

MATERIALS

PAPER
White Stonehenge

COLORS
Brick Red, Brown, Shadow, Tan

OTHER
craft knife, pencil

1 SKETCH AND FILL IN THE BRICK

Sketch the rectangular shape of the brick with a pencil, then fill in the entire surface with Tan. Add some Brown to the right side.

2 DEEPEN THE COLOR

With firmer pressure, deepen the Tan on the top and the side. With Brick Red, lightly add some color to the front of the brick with irregular patterns. Use Shadow to create the dark edges on each side of the brick.

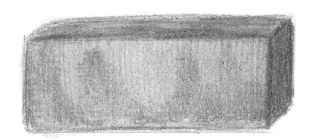

3 CREATE PATTERNS AND SHADOW

Build the color of the brick by adding Tan, Brick Red and Shadow. Create the patterns by overlapping the colors. Carry these colors onto the top and the side. Deepen the dark edges of the brick with Shadow. To create the tiny light edges of the brick, scratch them in with a craft knife along the dark edges.

Make a small shadow underneath the brick with Shadow. This is a perfect color not only for shadows, but for the mortar in between bricks.

Glass

Drawing shiny things requires the burnishing technique. Firm pressure must be applied to make the colors smooth and even.

Look at the close-ups of this drawing on the next page for explanations of the approaches used for each area.

GLASS RARELY LOOKS THE SAME TWICE

I have used this decanter as a subject for numerous art pieces. The actual color of the decanter is various shades of blue, going from light to dark. But because of its irregular shape and transparent glass, it looks different every time you look at it. A friend of mine took an entire series of photos of this decanter in various angles and lighting. Each one came out looking quite different. Some were very dark, and others, such as this one, looked like a rainbow of different hues.

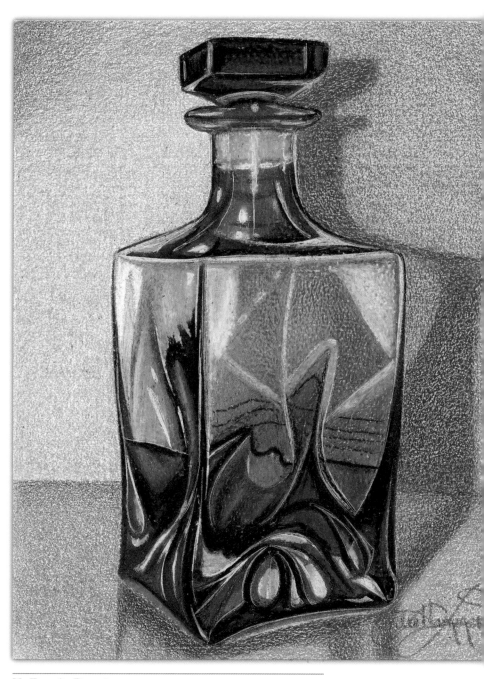

My Favorite Decanter
Crayon on illustration board, 10" × 8" (25cm × 20cm)

COLORS USED: (decanter) Aquamarine, Black, Blue, Blue Violet, Peach, Red Violet, Vivid Violet, White, Wild Strawberry; (background) Brick Red, Goldenrod, Melon, Pink Flamingo; (table) Brick Red, Melon, Orange, Yellow

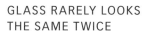

BURNISHING FOR DARK AND OPAQUE
Because you are not seeing through it, the colors appear much richer, darker and smoother. I used heavy burnishing with solid colors to make them fill in and look brilliant. To get the thin white lines within the patterns of color, I used a craft knife to scratch them out.

LAYERING FOR TRANSPARENCY
I used one color over the top of another and allowed the colors to speckle. This gives the glass the illusion that you can see through it, that you can actually see the front and back surfaces at the same time. I used the craft knife to scratch away the light lines and patterns.

COMBINATIONS CREATE DIMENSIONS
This area is a combination of the two techniques seen above. The deep colors on the lower part of the bottle neck have been built up and burnished. The upper portion is layered, creating the illusion of transparency. The little white lines scratched into the surface give the neck of the bottle dimension, making it appear as a cylinder.

Visit www.artistsnetwork.com/newsletter_thanks for a free download of *The Artist's Magazine*.

57

Metal

Drawing a metallic surface is very much like drawing glass. Both surfaces are highly reflective and create extreme patterns of light and dark. When drawing an object in color, you must remember to look for colors reflecting from the object's surroundings.

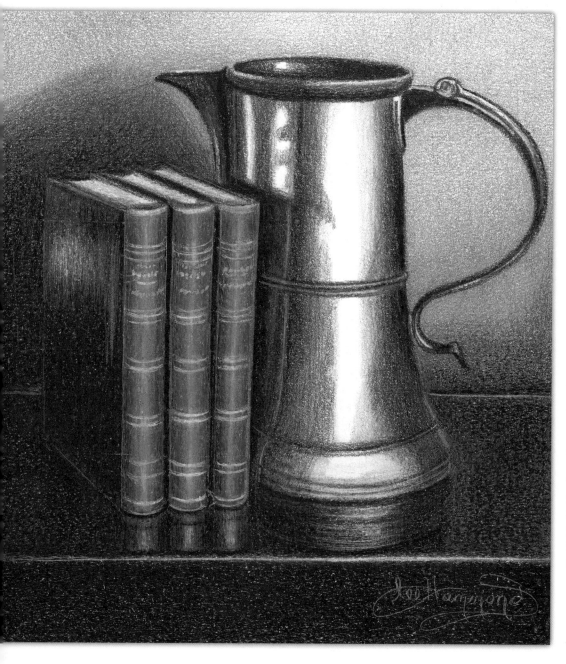

MANY COLORS CREATE DULL METAL

Even though this silver pitcher is metal and highly reflective, it is not slick and shiny like polished silver would be. This pitcher is brushed silver, so the surface is dull. Several colors were layered to make it look somewhat porous, instead of slick.

The little highlights in the handle were scratched out with a craft knife.

Silver Pitcher and Books
Crayon on Stonehenge paper
10" × 11" (25cm × 28cm)

COLORS USED: (pitcher) Black, Gold, Sea Green, White, Wild Strawberry; (books) Black, Dandelion, Red, Wild Strawberry; (tabletop) Black, Brick Red, Brown; (background) Black, Caribbean, Olive Green, Sea Green

Draw a Brass Horse

This brass horse was drawn from a statue at the art gallery. The graceful lines of the horse were exaggerated in the sculpture, and the light and dark patterns are amazing. This is the type of subject I love to work from. Use this graphed line drawing to create a drawing of statuary yourself.

MATERIALS

PAPER
White Stonehenge

COLORS
Antique Brass, Black, Burnt Orange, Cadet Blue, Chestnut, Tan, White

OTHER
kneaded eraser, pencil, ruler

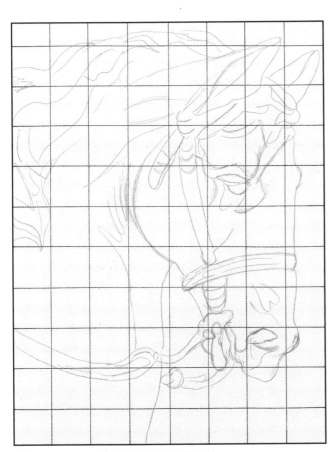

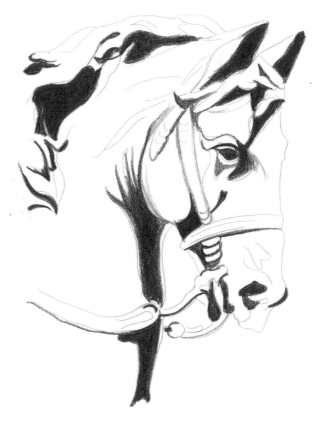

1 CREATE THE LINE DRAWING
Lightly draw a grid on your drawing paper using 1-inch (25mm) or larger squares. Use this drawing as a guide, and draw what you see in each square.

2 FILL IN PATTERNS
When you are happy with the accuracy of your line drawing, carefully remove the grid lines from your drawing paper and begin adding the crayon. Because the contrasts are so extreme in this piece, I used pure Black to start the patterns. Study the shapes here, and fill in the patterns.

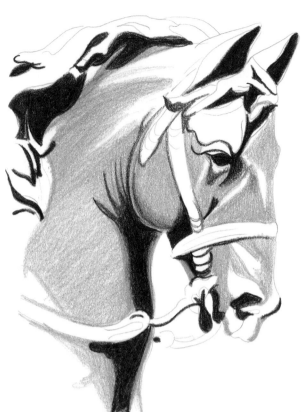

3 ADD THE UNDERTONE

With Tan, fill in the horse. This is the undertone for all of the colors that follow.

4 BUILD UP TONE

Now build up the brown tones of the horse. With Chestnut, go over the Tan color along the back of the neck. Move to the jaw and ear, and add some Chestnut there too. Add Chestnut to the front of the face.

Lee's Lessons

Figure drawing is an excellent way to practice your skills. Drawing from statuary is helpful because statues don't move, and the light source remains consistent.

5 BURNISH HIGHLIGHT AREAS AND ADD A BACKGROUND

Study this finished piece carefully. You can see how built up the colors are when compared to the previous steps. It takes many layers of color to make the tones so smooth and gradual. To give the horse a rich color, add some Burnt Orange to the neck area. Also use Burnt Orange in the highlight areas to make them more brilliant.

Use Antique Brass for the midtone color on the mane and add Black for the shadows. Then use White for the highlight areas. Repeat these colors for the bridle and rein.

To make the highlight areas of the statue appear smoother and more reflective, burnish White over them.

Since the upper outside edge of the statue is mostly white, place a Cadet Blue background color behind the horse to make it stand out.

Lee's Lessons

The muscular form is another example of why learning the five elements of shading is so important. Each rounded area of muscle is essentially a sphere exercise. Look closely, and you can see how the shadows and reflected light provide a rounded and three-dimensional appearance.

Visit www.artistsnetwork.com/newsletter_thanks for a free download of *The Artist's Magazine*.

61

chapter five
Nature

MUCH ART IS CREATED OUT OF THE BEAUTY OF NATURE. I FIND crayons wonderful for capturing scenery and all of the nuances and colors in nature.

FIVE ELEMENTS OF SHADING IN NATURE

Because of the association of crayons with color, flowers are the most commonly drawn subject matter. Look at this close-up of a rose, and you can see all five elements of shading hard at work.

Close-Up of a Rose
Crayon on Stonehenge paper, 10" × 11" (25cm × 28m)

COLORS USED: (rose) Blue Violet, Hot Magenta, Lavender, Mango Tango, Orchid, Peach, Vivid Violet; (background) Black, Green, Pine Green

Flowers

Flowers are fun and interesting drawing subjects because there are so many colorful varieties. When observing flowers to draw, keep in mind the overlapping petals that create hard edges of reflected light and cast shadows.

Flowers also have many different textures. To achieve depth and realism, it is best to use the layering technique to draw fuzzy surfaces and the burnishing technique to draw shiny, reflective petals.

COMBINE TECHNIQUES FOR VIBRANT FLOWERS

I chose white mat board so I could leave those areas of bright light uncovered for the lightest areas of the flower.

I burnished colors on the unopened bud to make them brighter and used a craft knife to scratch reflected light at the edges of the smaller leaves. The flower and the bigger leaf were drawn using the layering approach, giving them a softer appearance.

Drawing of a Hibiscus
Crayon on white mat board
16" × 12" (41cm × 30cm)

COLORS USED: (flowers) Black, Carnation Pink, Magenta, Maroon, Periwinkle, Red, Red Violet, Violet, Yellow; (leaves and stems) Black, Green, Green Yellow, Pine Green, Yellow Green; (background) Black, Blue Green, Green, Pine Green, Red Violet, Violet, Yellow Green

LAYERING CREATES SOFT PETALS

These deep and intense colors were done with multiple layering. The speckling effect of the crayon shows throughout. The petals are smooth, but not overly shiny. Layering portrays them best; burnishing would have made them look too slick.

Drawing of a Red Day Lily
Crayon on Stonehenge paper
11" × 14" (28cm × 36cm)

COLORS USED: (flower) Black, Blue Violet, Carnation Pink, Magenta, Maroon, Orange, Peach, Red, Red Orange, Violet Red, Yellow; (pods and background) Green, Scarlet, Sea Green, Shadow, Yellow, Yellow Green

Desktop Wallpaper

Download free desktop wallpaper of this and other images at http://AmazingCrayonDrawing. artistsnetwork.com.

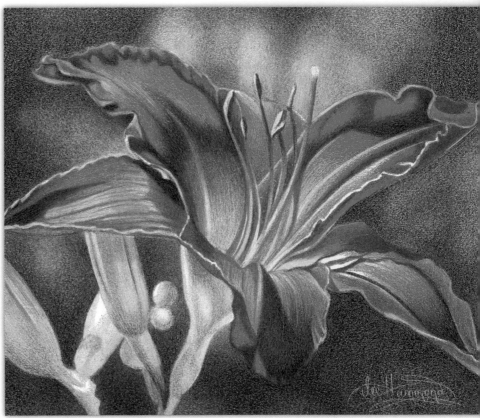

Draw a Flower

Create your own beautiful flower in crayon, using the grid method. It isn't as complicated as it looks. Keep a sharp point on your crayons and go slowly.

MATERIALS

PAPER
White Stonehenge

COLORS
Blue Violet, Dandelion, Mango Tango, Pine Green, Red Violet, Scarlet, Yellow Orange

OTHER
craft knife, kneaded eraser, pencil, ruler

1 CREATE A LINE DRAWING
Use this graphed line drawing as a guide to draw the flower. Lightly draw a 1-inch (25mm) grid on your drawing paper in pencil. When you are sure of the accuracy of your drawing, carefully remove the grid lines with a kneaded eraser.

2 ADD COLOR
Add a layer of Dandelion to the pods and the left side of the base of the flower, using firm pressure. The color needs to fill in and cover the paper.

Add Yellow Orange to the right side of the base of the flower, pressing firmly.

Move up to the petals of the flower. Fill in the two petals on the left with Mango Tango. Add this color to the center strip on the right petal.

With Scarlet, fill in the rest of the right petal. Also use Scarlet to outline the other petals of the flower. Use Mango Tango to outline the pods.

3 DEEPEN THE TONE AND ADD DETAIL

Fill in the petal on the far right with Red Violet. Add this color to the middle of the flower and down the center of the lower right side of the flower's base. Fill in the stamens with Yellow Orange. Use Dandelion for the tips of the stamens, since they are lighter there.

Use Blue Violet for the darker areas of the flower. These are shadows and recessed areas that help create the flower's roundness and form.

Use Pine Green for the pod and stem.

4 FINISH THE DRAWING

Continue to build up the color of the flower. You can see where the Blue Violet has been used over some of the colors to deepen them. On the petal on the far right, apply Blue Violet over the Red Violet and Scarlet.

On the petal on the far left, scratch out fine white lines with a craft knife.

Continue adding color to the base, stem and pods. A few streaks of green and orange are all it takes to make them look more realistic.

For the background, add a random light layering all of the colors in the flower. The overlapping colors create the illusion of more flowers and nature in the background.

Have fun when creating the backgrounds on your artwork. If yours doesn't look exactly like mine, it doesn't matter a bit. Experiment with color. Maybe you can create something even better.

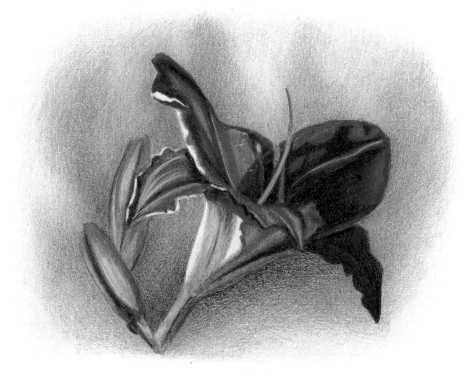

Visit www.artistsnetwork.com/newsletter_thanks for a free download of *The Artist's Magazine*.

65

Draw a Butterfly

Sometimes a subject that looks difficult to draw really isn't. Butterflies look extremely complicated, but I find them fairly easy to draw. This is because their patterns can be broken down into puzzle shapes. The black outlining of the colors goes on last, pulling everything together.

MATERIALS

PAPER
White Stonehenge

COLORS
Aquamarine, Black, Brown, Gold, Goldenrod, Periwinkle

OTHER
craft knife, kneaded eraser, pencil, ruler

1 CREATE A LINE DRAWING
Use this graphed line drawing as a guide to draw the butterfly. Lightly draw a 1-inch (25mm) grid on your drawing paper in pencil.

When you are sure of the accuracy of your drawing, carefully remove the grid lines with a kneaded eraser. Be sure not to inadvertently remove any of the important lines needed to create the patterns.

2 ADD LIGHTER COLORS
Add the lightest color first. Start with Goldenrod and place it on the body and upper portion of the wings.

Add Brown along each side of the body and onto the head.

Add Gold to the outside patterns within the wings.

Add Aquamarine to the wings. For the darker areas of blue, use Periwinkle.

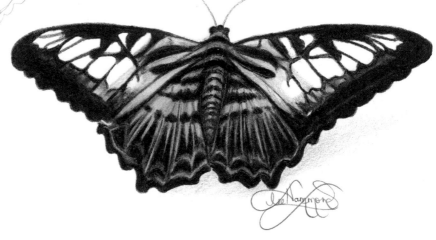

Lee's Lesson's

Whenever you are drawing something with patterns where black is the most dominate color, it is important to place the lightest colors down first. NEVER apply the black first; it will smear into the light colors and ruin them.

3 FINISH THE PATTERNS AND SCRATCH OUT LINES
When all of the lighter colors have been applied, it is time to add Black. With a sharp point, fill in the smaller lines and areas first. Continue to add Black to the patterns. Use a craft knife to gently scratch out the delicate lines in the patterns of the lower wing.

Draw a Butterfly and Flowers

Now let's combine the joy of drawing flowers with the beauty of a butterfly. This Tiger Swallowtail has wonderful patterns to draw. Use the grid method to capture all of the important lines and patterns of both the butterfly and the flowers, and then bring it to life with pretty colors.

MATERIALS

PAPER
White Stonehenge

COLORS
Aquamarine, Black, Green,
Olive Green, Orange, Red,
Red Orange, Yellow, Yellow Green

OTHER
kneaded eraser, pencil, ruler

1 CREATE A LINE DRAWING

Use this graphed line drawing as a guide to draw the butterfly. Lightly draw a 1- inch (25mm) grid on your drawing paper in pencil.

When you are sure of the accuracy of your drawing, carefully remove the grid lines with a kneaded eraser. Be sure not to inadvertently remove any of the important lines needed to create the patterns.

2 APPLY THE UNDERTONE

The predominate color, or undertone, to this entire piece is yellow. Apply a light layer of Yellow to the butterfly. When filling in the little areas, don't worry about going outside of the lines. The Black will cover it later, and you can be more controlled then.

Apply some Yellow into the flowers surrounding the butterfly. The edges of the flowers are white, so leave it open. Don't take the Yellow clear to the edge.

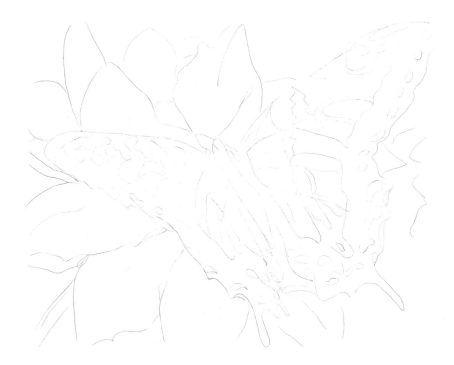

Visit www.artistsnetwork.com/newsletter_thanks for a free download of *The Artist's Magazine*.

67

3 CONTINUE ADDING COLOR

Add some Orange to the butterfly and flowers. Use a light touch to keep the color soft and subtle.

Fill in the small dots on the bottom of the wings with Aquamarine and Red Orange. These need to be a bit brighter, so apply more pressure on the crayon.

4 FILL IN THE PATTERNS AND BACKGROUND

This is where the color starts to come alive. Add the colors in the background first, before adding any Black to the drawing.

Start with Green and fill in the patterns. Add Olive Green to the small areas in the upper left and far right. Add Yellow Green and Red. At this stage, it is very much like a coloring book. Have fun!

When the background colors have been blocked in, take a sharp Black crayon and outline the shapes of the butterfly.

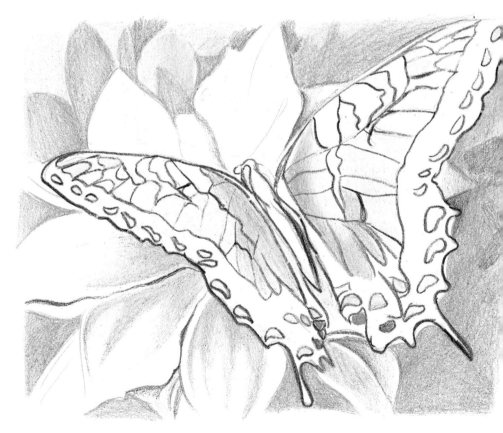

68

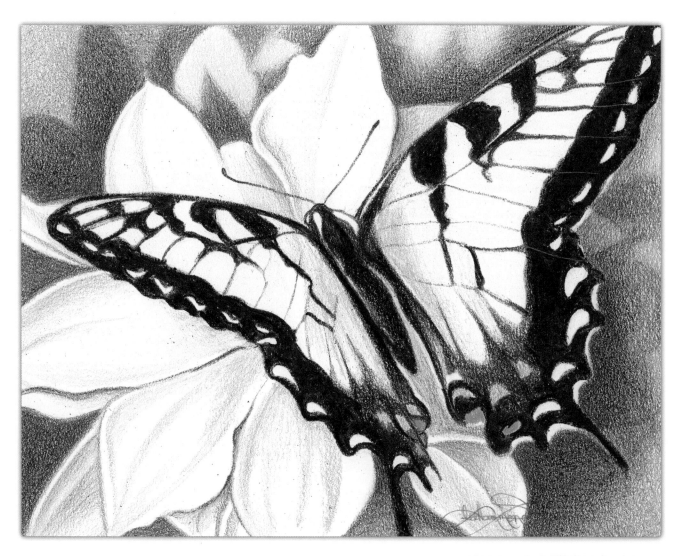

5 ADD FINISHING DETAILS

Study this finished piece and see how Black was used to bump up the realism. It is what pulls everything together in this drawing.

To finish, start with the background. Add a light layer of Black over the other colors so they take on a darker, muted appearance. Keep a sharp point on the crayon, and carefully go over everything to give the out-of-focus illusion and subtle shadowing.

Move to the petals of the flowers, and add shadows under them. Use fine Black lines to separate each petal. With a very light touch, use Black to create shadows on the petals to give them dimension and form.

Finish the butterfly by adding intense Black. Fill in the patterns using firm pressure so the Black fills in completely. Be sure to follow the patterns exactly.

Lee's Lessons

Be sure to sweep away the flecks of crayon with a drafting brush as you fill in the dark areas. These small flecks can grip the paper and become permanent if not addressed immediately. If they are a bit stubborn and are not easily whisked away with the brush, try picking them off with the craft knife before brushing.

Sometimes the little flecks become a problem and cannot be removed no matter what. That is when you must be creative and consider adding a background color to cover them up.

Visit www.artistsnetwork.com/newsletter_thanks for a free download of *The Artist's Magazine*.

69

Draw More Butterflies

The first butterfly you drew was much simpler than this one. It was done using the layering technique and few colors, and it did not include a background. This one has much more color and requires burnishing to make the colors vivid and bright. To enhance the effect, I used complementary colors. By making the background out of shades of green and violet, the orange and red colors of the butterfly stand out even more.

Although this drawing is more complicated than the first butterfly we drew, it is still easy and fun to do. Follow along to create this beautiful Red Admiral butterfly.

MATERIALS

PAPER
White Stonehenge

COLORS
Black, Blue, Blue Green,
Red Orange, Yellow, Yellow Green,
Yellow Orange

OTHER
craft knife, kneaded eraser,
pencil, ruler

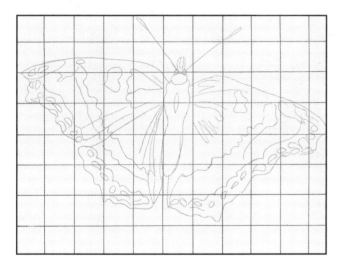

1 CREATE A LINE DRAWING
Lightly draw a grid on your drawing paper with a pencil. Make this drawing as large as you'd like (2-inch [5cm]) squares would look great). Carefully draw the shapes and patterns of the butterfly, one box at a time. When drawing butterflies, the patterns are of extreme importance, as they are unique to their particular species. They must be correct.

When you are sure of your accuracy, carefully remove the grid lines from your drawing paper with a kneaded eraser.

2 ADD COLOR
Always start with the lightest color. Apply Yellow to the wings and body.

Apply Red Orange heavily to the center of the wings, and lightly layer over the Yellow already applied.

Add Blue around the body and into the small spots around the wings.

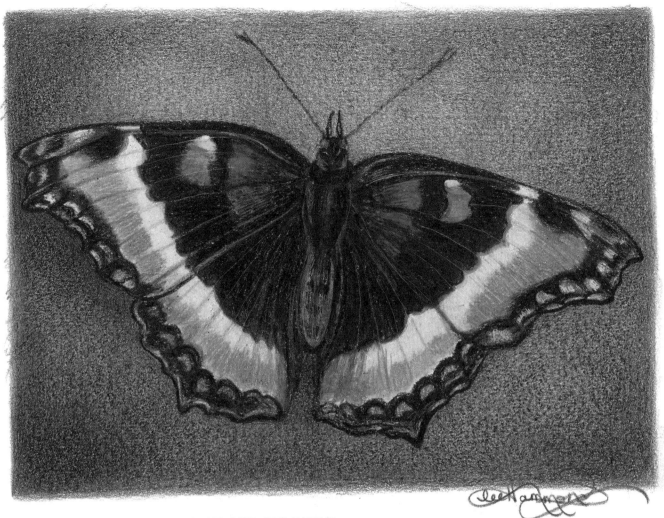

3 COMPLETE THE BACKGROUND AND ADD DETAIL

Before adding Black to the butterfly, complete the background. Start at the top with Yellow Green. Use the layering process with a sharp point to keep the tones even and smooth.

When you get to the midway point, switch to Blue Green and continue the layering process to the bottom. Once those two colors are evenly applied, layer Black on top to deepen the background. Darken the corners to create a visual framework, leading the eye into the center. Place some Black on the left behind the butterfly to act as a shadow.

Once the background is complete, add Black to the butterfly to tie it all together. Use firm pressure. Overlap some of the colors already applied. Then with a craft knife, scratch out the Black in the body and create fine lines in the wings. This allows the lighter colors you placed first to come through the Black, making it look delicate and realistic.

Lee's Lessons

When you have color combined with intense Black, it is very important to apply the lighter colors first.

Visit www.artistsnetwork.com/newsletter_thanks for a free download of *The Artist's Magazine*.

71

Landscapes

Landscapes offer a wealth of material for an artist to ponder.

Study the following pages and examine how each landscape was created. You will be able to clearly see all three crayon techniques (layering, burnishing and scratching) at work, and the way crayon can be used to capture all types of scenery.

SUNSETS

This is a perfect example of complementary colors hard at work, enhancing one another.

The yellow tones contrasting against the violet show how opposites attract.

Look at the area of the sun rays, and you can see where the craft knife was used to scratch through the color of the trees. This technique gives the illusion of sunlight coming through the trees.

Sunglow
Crayon on Stonehenge paper
14" × 11" (36cm × 28cm)

COLORS USED: (sky) Dandelion, Orange, Yellow, Yellow Orange; (foreground) Black, Blush, Carnation Pink, Mango Tango, Mauvelous, Plum, Violet, Yellow; (trees) Beaver, Black, Brown, Chestnut, Orange

SCRATCHING FOR MOUNTAIN LANDSCAPES

Crayon is perfect for this type of drawing because you can scratch into the wax to create illusion and texture.

Working on the peaks of the mountains, first a heavy base of Carnation Pink was applied, and then the darker purple colors were layered on top. When I used the knife to scratch, the pink underneath was revealed, creating the looks of the mountain peaks and ridges.

To give the illusion of water, I scratched reflections horizontally across the image.

Mountain Scene
Crayon on Stonehenge paper, 11" × 14" (28cm × 36cm)

COLORS USED: (sky) Carnation Pink, Melon, Red Violet, Violet, Yellow; (mountains) Black, Blue, Blue Violet, Carnation Pink, Magenta, Red Violet; (trees) Black, Blue; (grass) Black, Blue, Green, Melon, Violet; (water) Black, Blue Violet, Carnation Pink, Magenta, Melon, Red Violet

Visit www.artistsnetwork.com/newsletter_thanks for a free download of *The Artist's Magazine*.

73

Draw a Sunset

Now let's create a landscape. One of the most popular types of land-scapes is a tropical scene. This sunset is a fun one to do. It requires all three crayon techniques, though layering is the most important. Follow along to create the sunset.

MATERIALS

PAPER
White Stonehenge

COLORS
Black, Blue Violet, Carnation Pink, Orange, Red Violet, Violet, Yellow

OTHER
craft knife, kneaded eraser, pencil, ruler

1 SKETCH AND ADD COLOR

With a pencil and a ruler, draw a horizon line across your draw-ing paper well below the center mark. Lightly draw in the shape of the shorelines. Start with the sky, applying the lightest colors first.

Use Yellow to create the area where the sun is located. Leave the sun white. Add Yellow in a band across the paper.

Move up to the upper area of the drawing and apply Carnation Pink all the way across, and down to the Yellow. Skip the Yellow area, and apply Carnation Pink from the Yellow down to the shoreline.

Fill in the area of the water with Yellow, using a bit more pres-sure. Add a layer of Orange over the Yellow with horizontal strokes.

With Blue Violet, draw the horizon line to separate the water from the sky. Fill in the foreground of the beaches with Blue Violet as well.

2 DEEPEN THE TONE

Starting with the sky, deepen the colors of the sunset. Add more Yellow to the band of light, avoiding the sun, which is still left white. Deepen the Carnation Pink above and below the Yellow.

Add Red Violet to the sky, overlapping the Carnation Pink. Allow a light area to show, and move up to the top of the sky. Continue with Red Violet to darken the top. With Violet, go from the top of the paper and fade it down. Allow the light spot to remain.

With Red Violet, streak some color into the Yellow area of the sky and into the Yellow of the water. This creates an illusion of cloud streaks and water reflections.

Go down to the ground and overlap Red Violet onto the Blue Violet already applied. Keep this color closer to the shoreline.

3 ADD DETAIL TO FINISH

Continue building the colors using the light layering technique. Allow the colors to overlap one another. Do not attempt to add the trees until this is complete.

Deepen the color of the shoreline with a light layering of Black. Carefully erase the pencil line you drew to represent the sun. To create the sun rays, use a craft knife to scratch them out in a wagon wheel formation.

Use Black to add the palm tree and small trees on the right. (Practice a palm tree or two on another piece of paper until you get the hang of it.) Don't forget to add the Black area surrounding the tree trunk on the ground. It is burnished, but it still must look textured. You don't want it to look like a hole.

Draw the smaller trees on the right more in clumps like the shape of a bush. Scratch light areas in with a craft knife to reveal the pink tones of the sky underneath.

Visit www.artistsnetwork.com/newsletter_thanks for a free download of *The Artist's Magazine*.

75

Draw a Mountain Scene

This mountain scene is not as complicated as the previous one. The simple color scheme and layering techniques used to create it, make it a fairly easy project.

Follow along to create the mountain scene.

MATERIALS

PAPER
White Stonehenge

COLORS
Carnation Pink, Indigo, Red Violet,
Robin's Egg Blue

OTHER
kneaded eraser, pencil

1 SKETCH THE SCENE

With a pencil, lightly sketch in the shapes and patterns of the mountains. Notice how the shapes slope down to the left.

Once you have a light sketch, start applying the colors to the sky. Begin with Carnation Pink using a horizontal stroke. This color creates the look of wispy clouds.

Switch to Robin's Egg Blue, and apply it to the sky. It is deeper in color behind the mountains and gets lighter as it goes up.

Move down to the lower portion of the drawing and apply the Robin's Egg Blue to the snow slope and to the lake.

2 CONTINUE ADDING COLOR

Continue to apply Robin's Egg Blue to the mountain range, mostly on the right side of each peak. Add Carnation Pink to the left sides of the peaks and to the snow slope below.

Add some Indigo to the top of the sky using a light layered approach. Continue with Indigo, and add lines to the mountains and lake with firmer pressure. Keep a sharp point on the crayon so you have control over the width of the lines.

At this stage it may look a bit awkward because of all the lines. Do not stop! The next step pulls it all together.

Learn more at http://AmazingCrayonDrawing.artistsnetwork.com.

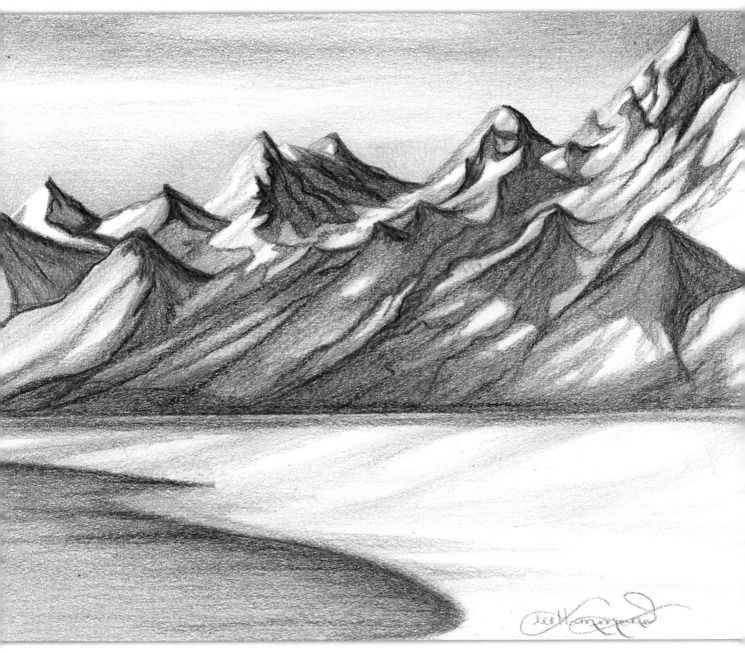

3 LAYER IN DARK TONES TO FINISH

With Indigo, carefully apply the dark tones to the mountain range and the water. Use a layered approach to keep the color even and smooth. Be sure not to fill it in too much. It is important to leave areas open with the white of the paper showing in order to create the look of snow. Deepen the pink color along the base of the mountain with a bit of Red Violet.

Visit www.artistsnetwork.com/newsletter_thanks for a free download of *The Artist's Magazine*.

77

chapter six
Animals

DRAWING ANIMALS IN CRAYON CAN BE PURE JOY! ANIMALS ARE favorite subjects for most artists, and the variety offers endless art possibilities. In this chapter I have tried to provide not only a variety of species, but also a variety of colors, textures and techniques.

ADJUST TECHNIQUES FOR THE SUBJECT

Notice how smooth the tones are here. This is due to the layering process. To achieve tones as smooth and even as this, you must continually maintain a sharp point on your crayon.

Drawing of a Tree Frog
Crayon on Stonehenge paper
14" × 11" (36cm × 28cm)

COLORS USED: (frog) Black, Brown, Burnt Orange, Caribbean Green, Chestnut, Goldenrod, Sea Green, Yellow Green; (leaves) Black, Burnt Orange, Green, Pine Green, Yellow Green; (background) Black, Green, Green Yellow, Pine Green, Yellow Green

Lee's Lessons

Keep a sharp point on your crayon at all times to make color as smooth and gradual as this. A border box adds a graphic element to the composition.

Birds

Birds are extremely varied, and there are literally thousands of shapes, colors and textures to pick from when drawing them. The following pages give you a variety of birds to look at and draw.

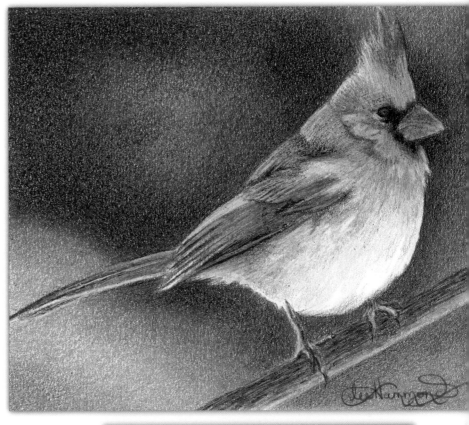

LAYERING AND SCRATCHING
Layering was used to keep the soft muted colors looking subtle. In the smaller feathers, scratching was used to create the small white lines.

Female Cardinal
Crayon on Stonehenge paper
8" × 10" (20cm × 25cm)

COLORS USED: (cardinal) Atomic Tangerine, Black, Dandelion, Red, Shadow, Tumbleweed, Yellow (a small amount of Blue Green was applied to the eyeball); (branch) Black, Bittersweet, Brown, Tan; (background) Black, Blue Green, Pine Green, Sea Green

BURNISHING
Burnishing was used to build up the deep colors. Scratching was also used, especially in the area around the eye where the light-colored feathers overlap the red tones.

Portrait of a Macaw
Crayon on Stonehenge paper, 11" × 8½" (28cm × 22cm)

COLORS USED: (parrot) Black, Cerulean, Maroon, orange, Red, Scarlet, Sky Blue, Sunset, Yellow Orange; (beak, claw and apple) Black, Green, Gray, Inchworm, Jungle Green, Peach; (background) Green, Pine Green, Yellow Green

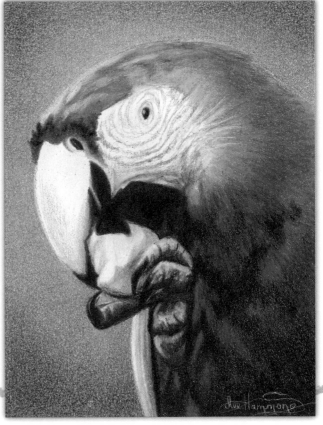

Draw a Toucan

Some birds have feathers that are so close together and even in color that they appear solid. This toucan is one of them. The deep black color of the bird looks as smooth as silk. The bright colors of the beak and face contrast sharply against the deep black, creating a striking visual effect.

MATERIALS

PAPER
White Stonehenge

COLORS
Black, Brick Red, Brown ,Caribbean Green, Dandelion, Gold, Mango Tango, Olive Green, Orange, Red, Tan

OTHER
kneaded eraser, pencil, ruler

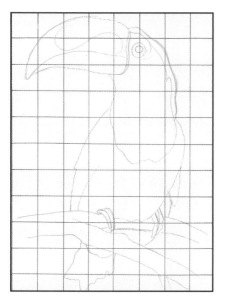

1 CREATE A LINE DRAWING
Use this graphed drawing to create an accurate line drawing of your own. Lightly draw a grid on your drawing paper with a pencil. Draw the shapes of the toucan, one box at a time. When you are sure of your accuracy, carefully remove the grid lines from your drawing paper with a kneaded eraser.

Lee's Lesson

Whenever you need to use Black along with lighter colors in your drawing, the lightest colors should always be applied first to prevent smearing. Use a drafting brush to clean away the debris as you work, so the small loose flecks do not stick and become permanent.

2 APPLY COLOR
Start with the lightest colors first. (Except for the eye. I like to have it in place, just to instill the personality right away. Use Black for this.) With Dandelion, apply even coverage to the face and neck area of the toucan. Move to the beak, and apply Dandelion to the upper and lower portions. Add some to the feet.

Switch to Orange, and layer it over the face and neck area. Move back to the beak and apply the Orange to the tip, and the distinct teardrop shape of the upper beak. Layer some Orange over the yellow color of the lower beak.

Go down to the branch and apply Dandelion to the upper edge of the two limbs. Apply Tan to the rest of it.

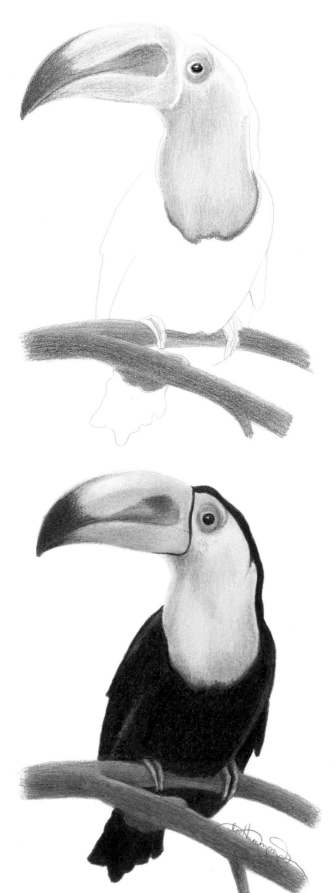

3 DEEPEN COLOR AND ADD BRANCHES

Start applying more color to the chest and neck area. With Olive Green, apply a small amount to the lower portion and left side. This gives the look of a subtle curve.

With Caribbean Green, go around the eye, leaving a small amount of white around it. Use a faint line of Black to circle the eye, over the Caribbean Green to create texture.

Overlap the yellow color to the right of the eye with Caribbean Green. It now looks like yellow-green because the two colors mix together.

To deepen the color of the lower beak, layer some Olive Green over the yellow tones.

Add a small band of Brick Red where the colored area meets the Black area of the chest.

Now move to the beak. Apply Caribbean Green to the area where the beak connects to the face. Overlap the yellow color and carry the Caribbean Green down the beak as shown. Again, the colors blend together to create yellow-green.

Overlap the Brick Red onto the Orange seen on the tip of the beak. Allow a small amount of Orange to show along the edges. To separate the upper and lower beak, draw a very faint line with Brick Red.

To create the look of the tree limbs, refer back to the long cylinder exercises. Use the five elements of shading to make the limbs look rounded and dimensional. Apply Brown to the limbs. Allow the light edge of reflected light to show through in areas to make them look rounded. Keep the point on your crayon sharp, and apply the lines horizontally to create the look of tree bark and texture.

Create the small red area of the bird peeking out from behind the branch with Mango Tango and Red.

4 ADD BLACK AND FINISHING TOUCHES

Go over everything you have already done, and deepen all of the colors one more time. The colors need to be brilliant.

When you are happy with the color, move on to the body. Fill in the rest of the bird with pure Black, using firm pressure. Use Gold to create the light areas that separate the body from the wings. Metallic colors go over other colors well and are very opaque.

Move to the branch and finish it by adding a small amount of Black. Allow some of the lines to show to create the look of tree bark. Go up to the feet, and place shadows between and under the toes with Black.

Visit www.artistsnetwork.com/newsletter_thanks for a free download of *The Artist's Magazine*.

81

Draw a Hawk

The highly textured feathers combined with the heavily burnished eye make this hawk a challenge to draw.

MATERIALS

PAPER
White Stonehenge

COLORS
Aquamarine, Bittersweet, Black, Brown, Goldenrod, Tan, White, Yellow

OTHER
craft knife, kneaded eraser, pencil, ruler

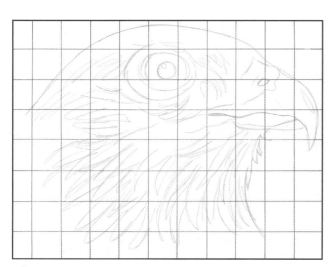

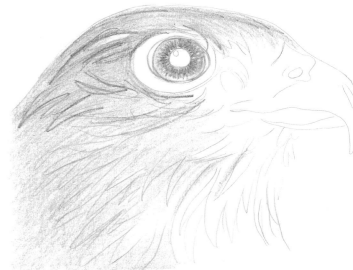

1 CREATE A LINE DRAWING

Use this graphed drawing to create an accurate line drawing. Lightly draw a grid on your paper with a pencil. Draw the shapes of the hawk, one box at a time. When you are sure of your accuracy, carefully remove the grid lines from your drawing paper with a kneaded eraser.

2 COLOR THE EYE AND FEATHERS

Begin with the colors of the eye. Start with Goldenrod and base in the entire area of the iris (the colored part). Apply Bittersweet over the Goldenrod. It should radiate outward from the pupil (the black area) like a starburst. Repeat the strokes with Brown to develop the color and pattern of the eye.

Move down to the head, and apply a rough application of Tan. This will be the foundation color for the feathers. Add Brown to the top and the left side of the head using quick strokes. This is the start of the feathers.

Paint Animals With Lee

Watch a free video preview of *Painting Animals in Acrylic With Lee Hammond* at http://AmazingCrayonDrawing. artistsnetwork.com.

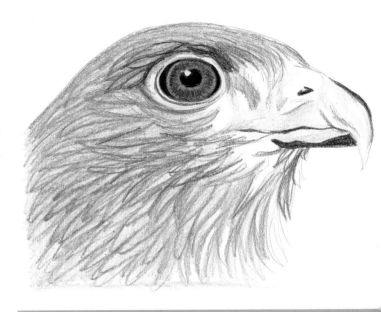

3 DEEPEN THE COLOR AND ADD TEXTURE

Finish the eye by adding the pupil with Black. Make the eye look real by burnishing over the colors with White to make them smooth. Repeat the colors if they look washed out. Then add a small amount of Black on top of that, using the same starburst pattern. Continue with Tan, but this time use deliberate strokes that will represent the shapes of the feathers. Follow the pencil lines from the line drawing you created with the grid. It's okay for them to show at this point; they will be hidden by darker colors later. Use Brown to further the texture.

The hawk is a bit rough looking at this stage. Add Black around the eye and in the face, making strokes in the shapes of feathers.

Move to the beak, and add Aquamarine to the upper and lower beak areas. Apply a small amount under the eye and into the face as well. In the area where the face and the beak meet, apply a small amount of Yellow.

Lee's Lessons

When it's time to add the color, start with the eye. Whenever I am drawing something with a face, I start with the eyes to capture the soul and character of my subject.

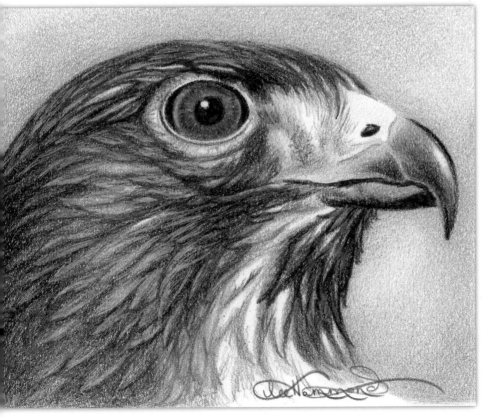

4 ADD THE BACKGROUND AND FINISHING DETAILS

In the finished piece you can see how the feathers have been built up using repetitive strokes and colors. The more you do, the more realistic it looks. If it gets too filled in, take a craft knife and gently scrape out some of the lighter feathers.

Finish the beak by adding Black to the edges and the tip. Allow the white to show where the highlight is. Add a small amount of Tan inside the nostril area.

Slowly layer Tan and Aquamarine in the background, allowing the colors to overlap one another. The smoothness of the background contrasts with the texture of the bird, making it really stand out.

Visit www.artistsnetwork.com/newsletter_thanks for a free download of *The Artist's Magazine*.

83

Draw Dogs

Drawing pets in crayon can be awesome! Follow along to draw the King Charles pups.

MATERIALS

PAPER
White Stonehenge

COLORS
Bittersweet, Black, Brown, Cornflower, Mauvelous

OTHER
craft knife, kneaded eraser, pencil, ruler

Lee's Lessons

To create the look of hair or fur, the crayon lines must follow the direction of the hair's growth.

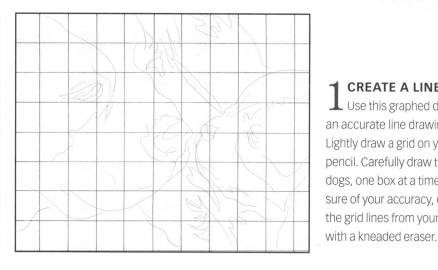

1 CREATE A LINE DRAWING
Use this graphed drawing to create an accurate line drawing of your own. Lightly draw a grid on your paper with a pencil. Carefully draw the shapes of the dogs, one box at a time. When you are sure of your accuracy, carefully remove the grid lines from your drawing paper with a kneaded eraser.

2 ADD FUR AND APPLY COLOR
With Brown, add the hair. You can see how the crayon lines are already creating the look of long fur.

Add Brown to the eye of the puppy, using more pressure to deepen the color. Then add Brown to the noses of both pups.

Apply Black to the eyes and noses of the dogs. The areas around the pupils of the eye and inside the nostrils are applied with more pressure. The areas around the nose and in the ears are layered more lightly.

Some of the pencil lines will still be visible; the colors that follow will cover them up.

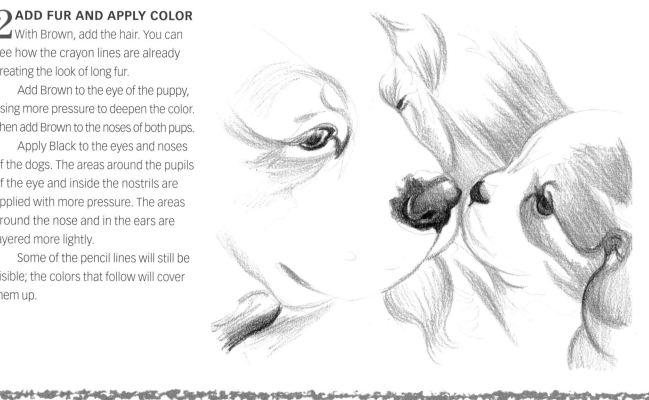

Learn more at http://AmazingCrayonDrawing.artistsnetwork.com.

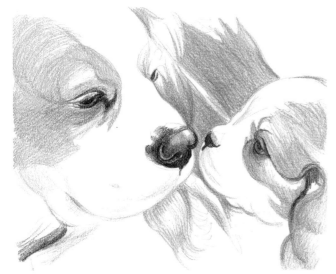

3 BUILD UP COLOR

To build up the colors of the dogs, add a layer of Bittersweet to the drawing. Be sure to apply this color the same way, going with the direction of the hair's growth. The addition of one layer of color changes the look of this drawing dramatically.

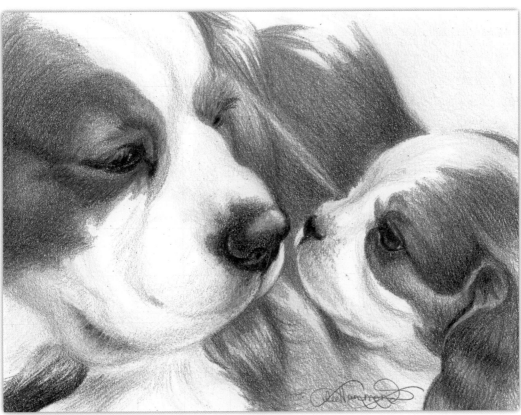

Lee's Lessons

It is easy to create realism by layering one color over another. Single colors can have a tendency to look flat. Add colors in layers builds dimension.

4 SCRATCH IN DETAILS

Continue to add more Brown and Bittersweet to fill in the colors. Maintain a sharp point on your crayon. Keep the direction of the crayon marks going with the hair.

To darken the Brown areas, add a light layer of Black. This helps create the roundness and form of the heads.

In the white areas of the dogs where the paper is still exposed, use a small amount of Cornflower to give that area more shape as well.

Around the muzzle and mouth regions, use a small amount of Mauvelous. This subtle pink color helps make this area look soft and warm.

Use the point of a craft knife to scratch small hairs into the drawing. If you look closely at the eyes of the mommy dog, you can see some eyelashes have been created. Use scratching to bring out a very fine light edge around the eyes of both dogs, and around their mouths to create whiskers. Also scratch some fine lines into the fur, especially in the ears.

Visit www.artistsnetwork.com/newsletter_thanks for a free download of *The Artist's Magazine*.

85

Draw a Panther

This drawing of a panther is a favorite of many. I use it to bring awareness of the need to protect the panther population around the world. Though it calls for similar colors to the dogs demonstration, the panther's short hair requires a fine layering of color instead of long strokes to make it look smooth. You will use three techniques to finish this drawing: layering for the fur, burnishing for the eyes, and scratching for the whiskers.

MATERIALS

PAPER
White Stonehenge

COLORS
Black, Brick Red, Brown, Fuzzy Wuzzy, Olive Green, Peach, Periwinkle, White

OTHER MATERIALS
craft knife, kneaded eraser, pencil, ruler

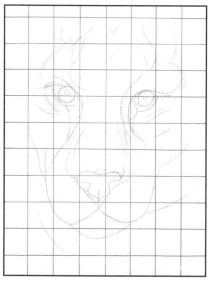

1 CREATE A LINE DRAWING

Use this graphed drawing to create an accurate line drawing. Lightly draw a grid on your paper with a pencil. Carefully draw the shapes of the panther, one box at a time. When you are sure of your accuracy, remove the grid lines from your drawing paper with a kneaded eraser.

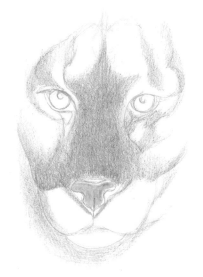

2 BEGIN ADDING COLOR

Begin adding the colors of the panther slowly and lightly. With a sharp point, fill in the panther with Brown. Use vertical strokes to follow the natural growth of the fur. If the lines show, they become part of the look of the fur.

Fill in the nose with a firm application of Peach.

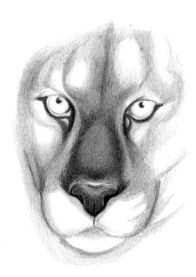

3 DARKEN THE TONES

Using Fuzzy Wuzzy, continue layering color, going over the Brown already applied.

With Black and a sharp point, develop the darker tones on the nose, leaving the Brown exposed in the center. Outline the eyes and add the pupils. Finish the nose before moving to the eye.

Go over the Peach applied to the nose with Brick Red. Add a small amount of Black over the Brick Red in the lower area. Use a craft knife to gently scratch in reflected light along the edges of the nostrils.

A

B

C

4 COMPLETE THE EYES

The colors in the eyes are Olive Green and Brick Red combined with White.

A: With Olive Green, add circular strokes around the pupil. With a very sharp point and Brick Red, add delicate circular lines along with the Olive Green.

B: Burnish over the colors in the eye with White. This makes the eye look shiny and reflective. After you have added White, deepen the Black around the eye.

C: Reapply both Olive Green and Brick Red. To make the eye even more intense, add a very small amount of Black over the Olive Green to deepen it. Burnish more White to the catch the light and make the eye even shinier.

Do the same to the other eye.

5 SCRATCH THE WHISKERS AND HAIRS

Finish the panther by continuing to build the colors of the fur with light layers. Maintain a sharp point on your crayons.

Shadow the muzzle area with a hint of Periwinkle to help that area appear rounded. Once the tones have been built up to the finished stage, take a craft knife and carefully scratch in the whiskers, chin hairs and eyelashes. Add a few dark whiskers with thin, quick strokes where they overlap the light areas of the face.

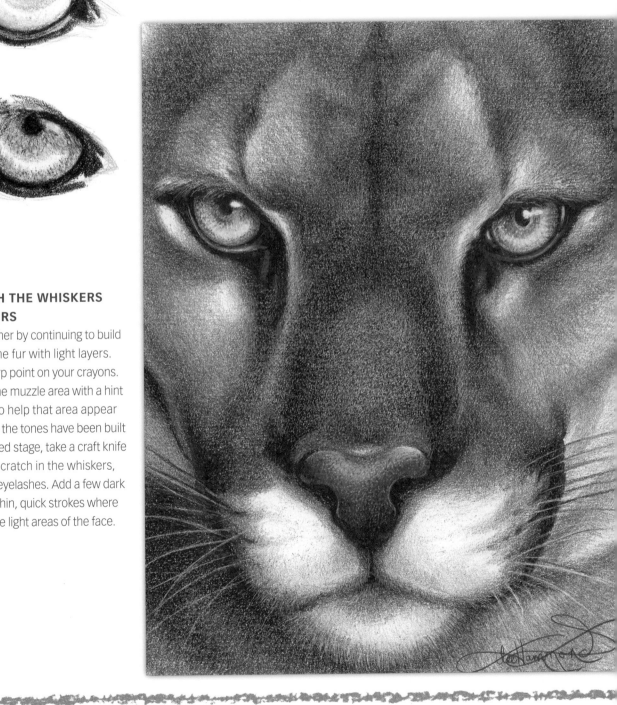

Visit www.artistsnetwork.com/newsletter_thanks for a free download of *The Artist's Magazine*.

87

Draw a Lion

Long hair is actually easier to create than short hair. Unlike short hair, longer hair is drawn using quick strokes, building them up over one another. It is not necessary to be exact.

MATERIALS

PAPER
White Stonehenge

COLORS
Aquamarine, Black, Brown, Goldenrod, Indigo, Peach

OTHER
craft knife, kneaded eraser, pencil, ruler

1 CREATE THE LINE DRAWING
Use this graphed drawing to create an accurate line drawing. Lightly draw a grid on your paper with a pencil. Carefully draw the shapes of the lion, one box at a time. When you are sure of your accuracy, remove the grid lines from your paper with a kneaded eraser.

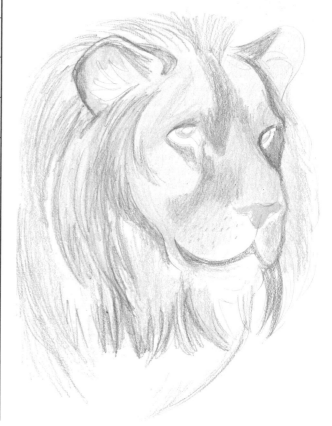

2 ADD COLOR
Fill in the facial area of the lion with Goldenrod, carrying it out into the mane area. With firmer pressure, add Goldenrod to the iris of the eyes.

Add Peach to the mane area using long sweeping strokes. Add it inside the ears and to the nose as well. This nose is almost the same as in the panther demonstration, only not as red.

Add Brown to the drawing to deepen the tones. Use my example as a guide.

Learn more at http://AmazingCrayonDrawing.artistsnetwork.com.

3 ADD HAIR AND DEFINE THE FEATURES

With Brown and a sharp point, continue adding more hair to the mane. Use long strokes with the crayons to build up the thick mane of the lion.

With Brown, fill in the inside of the ears. Add more Brown to the nose to deepen its color.

Switch to Black and outline the eyes, nose and mouth. With quick strokes and a sharp point, add some Black into the face and mane to build the look of dimension and hair thickness.

Begin layering color into the background with Aquamarine.

4 CONTINUE LAYERING AND ADD THE BACKGROUND

Finishing the drawing requires patience and many layers of color, using Goldenrod, Brown and Black. Use quick strokes and a sharp point at all times.

When the colors become built up, scratching is required to make the fur look realistic and textured. Scratch the fine lines with a craft knife going in the direction of the fur and hairs. The lighter colors below are then revealed, making the fur look thick and voluminous. Continue scratching until you get the look you want. If it isn't working well, you do not have enough crayon built up on the paper. Continue building and try it again.

Complete the background by continuing the layers of Aquamarine until it looks smooth and even. Deepen the color by adding layers of Indigo. Start at the edge of the lion and allow it to fade out into the Aquamarine. Add a layer of Black on top of that to further the depth of color. Allow the colors to fade into one another; you do not want to see where one tone ends and another begins.

Deepen the left corners of the drawing with layers of Black to give an illusion of depth and shadow.

Visit www.artistsnetwork.com/newsletter_thanks for a free download of *The Artist's Magazine*.

89

Animal Textures

What an amazing array of textures this drawing has! The very short fur is similar to that of the panther, but it is much deeper in color, and requires more layers of crayon.

The real interest of this particular drawing is in the ram's horns. The shapes are beautiful and the ridges create interesting textures and patterns.

While this is not a step-by-step project, it is a good one to practice on your own. Place an acetate grid over the top of the illustration in the book, and use the grid method to draw the ram.

Drawing of a Ram
Crayon on Stonehenge paper, 11" × 14" (28cm × 36cm)

COLORS USED: Black, Brown, Chestnut, Goldenrod

FUR

The fur, or hide, of the ram was built up in layers. Always start with the lightest colors first. In this area I used Brown first, then Chestnut, and then Black on top. Keep a sharp point on the crayons at all times, and make sure the strokes go in the same direction that the hairs are growing.

PATTERNS AND RIDGES

To draw the horns, place the lightest color (Goldenrod) first. Then use Chestnut and Brown to create the patterns and ridges. Scratch in the tiny light lines with a craft knife. These light lines meet the "edges" of the dark lines. This gives the horns an extra boost of realism by bumping up the texture and makes the darker lines look recessed.

HORNS IN SHADOW

This area of the horn was done much the same way, but it is in a shadow area so it appears much darker in color. The Goldenrod was applied first. Then Brown was applied as if shading the shape of a cylinder. The ridges and lines were placed last using Black, and the shadow was developed underneath. To make the dark lines look recessed, I scratched light lines along the edges of each one. This technique adds a lot of texture and dimension to your work.

Visit www.artistsnetwork.com/newsletter_thanks for a free download of *The Artist's Magazine*.

91

People

I HAVE SPENT MY ENTIRE CAREER TEACHING PORTRAIT DRAWING.
It is not something that is learned quickly or easily. If you want to be proficient in portrait drawing, I recommend referring to one of my other books first (*How to Draw Lifelike Portraits From Photographs* or *Draw Real People!*). There is a lot to learn about how to capture a likeness. Practice drawing the facial features and become familiar with the specific shapes associated with the face. It is impossible to draw a good portrait if the shapes are not accurate to begin with.

BROWN CREATES TRANSITIONS

I used a monotone color scheme of brown tones for this portrait. The brown tones act as a transition color, softening the black into the brownish tone of the paper more gradually. I also added some white to the face for one more layer of dimension. The white highlights the surfaces that protrude the most, giving the picture a more three-dimensional effect. By adding a light layer of white to the background, the entire drawing is tied together.

Samuel Clemens (Mark Twain)
Crayon on Moonstone Artagain paper
14" × 11" (36cm × 28cm)

COLORS USED: Black, Brown, Burnt Sienna, Tan, White

Monotone Portraiture

These two portraits are examples of monotone portraiture. Both were done on a toned paper that is a brownish-gray color. Using this color of drawing paper makes the white tones of the drawings show up more dramatically.

Although different approaches were used for the backgrounds of these two pieces, both make a wonderful portrait. There is no right or wrong way. Each technique offers a different possibility for the drawings.

BLACK BACKGROUND HIGHLIGHTS THE FACE

A student of mine did this portrait of Jack Nicholson. When drawing the face, she added a hint of brown for a midtone. But when it came to the background, she decided to add black instead of white, to help make the face stand out more.

Jack Nicholson
Artist, Stacy Bergh
Crayon on Moonstone Artagain paper
19" × 14" (48cm × 36cm)

COLORS USED: Black, Brown, White

Draw a Monotone Portrait

When you are first learning to draw portraits, I suggest starting out with a single color, or a monotone color scheme. This gives you the ability to practice drawing the facial features without the confusion of translating and depicting color. It will be similar to drawing the sphere because the sphere is seen repeatedly within the shapes of a face. Refer to it often because its elements are crucial to this exercise.

MATERIALS

PAPER
White Stonehenge

COLORS
Black

OTHER
kneaded eraser, pencil, ruler

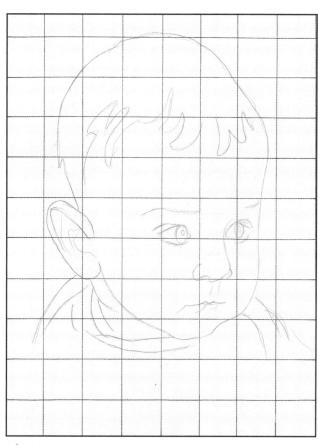

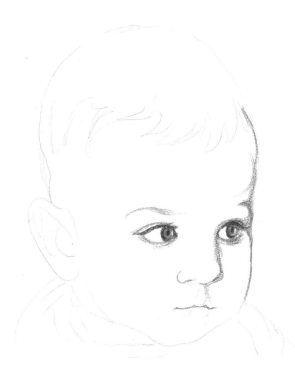

1 CREATE A LINE DRAWING

Create an accurate line drawing of a face. Lightly draw a grid on your paper with pencil. It is important when drawing people that you are extremely accurate with your shapes. Go slowly, and capture the shapes within each box as exactly as you can, before you start to apply the crayon. When you are sure of your accuracy, carefully remove the grid lines from your paper with a kneaded eraser.

2 RENDER THE TRIANGLE OF FEATURES

Start with the eyes. Maintain a sharp point on your Black crayon at all times to help with accuracy. When you finish the eyes, move down the right side of the nose and then down to the mouth. I call this the "triangle of features."

Learn more at http://AmazingCrayonDrawing.artistsnetwork.com.

3 APPLY FACIAL TONES

Once the triangle of features have been rendered, the tones of the face are applied. This is where you must remember the five elements of shading, for the face closely resembles the sphere. The roundness must be visible.

With a sharp point and gentle layering, build up the tones of the face to make it look dimensional. Add some lines to the hair, and then continue around the head, developing the shapes by going over the pencil lines with crayon.

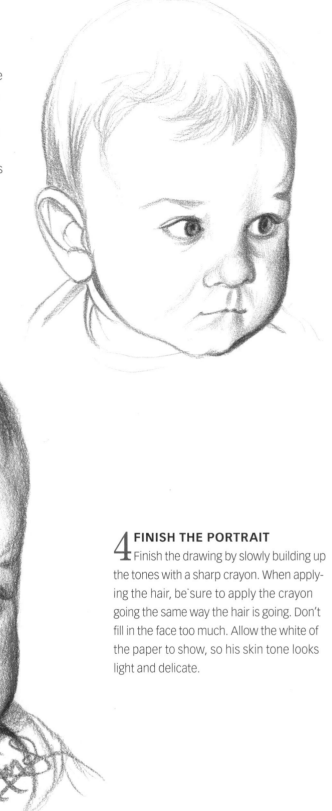

4 FINISH THE PORTRAIT

Finish the drawing by slowly building up the tones with a sharp crayon. When applying the hair, be sure to apply the crayon going the same way the hair is going. Don't fill in the face too much. Allow the white of the paper to show, so his skin tone looks light and delicate.

Draw a Color Profile

The addition of color makes portrait drawing a much bigger challenge. A sharp point and a light touch are essential to layering the colors evenly so they look smooth.

DEMONSTRATION

MATERIALS

PAPER
White Stonehenge

COLORS
Apricot, Caribbean Green,
Carnation Pink, Brown, Maroon

OTHER
kneaded eraser, pencil, ruler

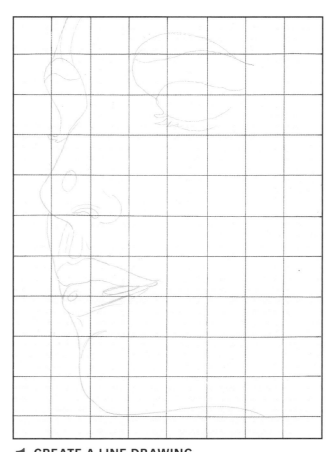

1 CREATE A LINE DRAWING
Use this graphed drawing to create an accurate line drawing of a face. Lightly draw a grid on your paper with a pencil. When you are certain your shapes are accurate, carefully remove the grid lines from your paper with a kneaded eraser.

2 APPLY TONE
With Brown, and a very sharp point, carefully apply the tones to the face as shown. Start with the eye area and work your way down. Use a light touch and deliberate strokes so you have a lot of control creating these shapes.

Learn more at http://AmazingCrayonDrawing.artistsnetwork.com.

3 ADD SHADOW AND SHADING

With Apricot, lightly apply the color of the skin tone and lips. Keep it light and smooth; don't get carried away and show a bunch of lines. It must appear even in tone.

Switch to Maroon, and lightly add the shadow shapes. Start with the eye area, allowing this color to overlap the Brown tones already applied.

Work your way down to the nose. Apply the Maroon as shown, making sure that an edge of reflected light is showing down the bridge of the nose. (Remember the five elements of shading.)

Move down to the mouth, and use Maroon to detail the lips. Overlap the Apricot already applied to the lips. Allow reflected light to show to create the fullness of the mouth.

4 FINISH THE DRAWING

Finish the face by building the colors of the skin to give her a rosy glow. Use Carnation Pink and a light touch to add color to her cheeks. Notice the rounded spherical shape. Overlap Carnation Pink into the other colors already applied to soften everything together. You can see this in the area of the eye, between the nose and upper lip, and below the mouth moving into the chin area. Leave the right side of the face unfinished so it fades into the paper.

Add Caribbean Green to the eyelid for the look of eye shadow, and then fill in the background with this color to finish the drawing.

Fun Features

To gather experience drawing faces, draw single features just for fun. I started my portrait education by drawing from magazines, forcing myself to draw every eye, nose and mouth in the entire book. Some turned out really good, while others turned out awful. Either way, you learn a lot. I suggest you do the same thing.

Trial and error is the best teacher in the world. Don't be afraid of failure, because there really is no such thing. Everything you draw contributes to your skill. You will never stop learning. Even after more than thirty years of drawing, I still discover new methods and tricks of the trade to pass along to my students. The work is never done, so just enjoy the process. Remember, "It's all in the doing!" It is important to draw for the pure joy of it.

Search for fun features in magazines and photographs, and fill an entire sketchbook with practice work. The more you do, the better you will become.

USE LAYERING AND BURNISHING TO CREATE PATTERNS

This drawing of an eye was fun to do, and it makes a cool drawing all by itself. I used heavy burnishing on the iris and layering for the white of the eye.

Here's Looking at You!
Crayon on Stonehenge paper, 8" × 10" (20cm × 25cm)

COLORS USED: (iris) Black, Brown, Mountain Meadow, White (heavy burnishing); (white of the eye) Periwinkle (layering); (remainder of eye) Black, Brick Red, Brown, Caribbean Green, Orchid, Peach, Red

BREAK FROM REALITY

This drawing shows you that everything doesn't have to be ultra realistic. While the face of this model looks fairly realistic, I chose to make the rest of the drawing more loose and whimsical. Give yourself permission to have fun by taking advantage of artistic license! I wanted this drawing to really catch your attention. I used the contrast between smooth, layered color, and bright colored burnishing. Notice how the lips stand out because of this. I also used hard lines and dark black in the hair to give this drawing a graphic quality, and a unique and eye-catching flair.

Kissy Face!
Crayon on regular Bristol, 10" × 8" (25cm × 20cm)

COLORS USED: (skin tones) Black, Bittersweet, Brown, Carnation Pink, Magenta, Melon, Peach; (eyes) Black, Brown, Green, Periwinkle; (lips) Black, Carnation Pink, Magenta, Red Violet, White; (hair) Black

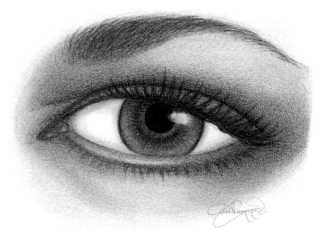

Color Portraiture

This is an example of what full portraiture can look like in crayon. Again, I cannot stress enough the importance of working knowledge when it comes to portraiture. Take the time to research and practice all of the facial features. Don't expect to dive in and become an accomplished portrait artist after just a couple of exercises. It is worth the investment of time to do the work and learn as you go. In time, it will all come together for you, and you will be able to draw wonderful portraits too.

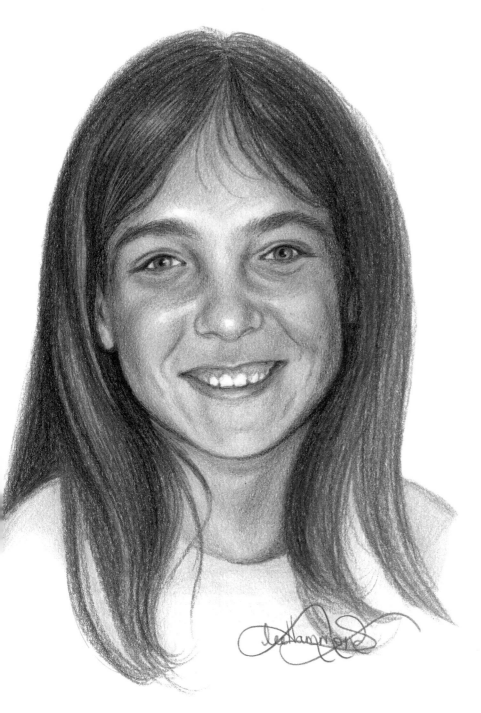

Caitlynn
Crayon on Stonehenge paper
14" × 11" (36cm × 28cm)

COLORS USED: (skin tones) Brick Red, Bittersweet, Brown, Carnation Pink, Peach; (eyes) Black, Brick Red, Brown, Olive Green; (hair) Black, Brown, Chestnut, Tan; (shirt) Robin's Egg Blue

Gallery

AS YOU CAN SEE, CRAYONS ARE TRULY FINE ART MATERIALS. MANY
people have a hard time believing that this quality of realism can be created
with what they consider to be a child's toy.

 I think the most exciting thing about being an artist is pondering what
to do next. With crayons, there is no limit to the amount of art that can be
created, and the type of subject matter that you can select. The possibilities
are endless.

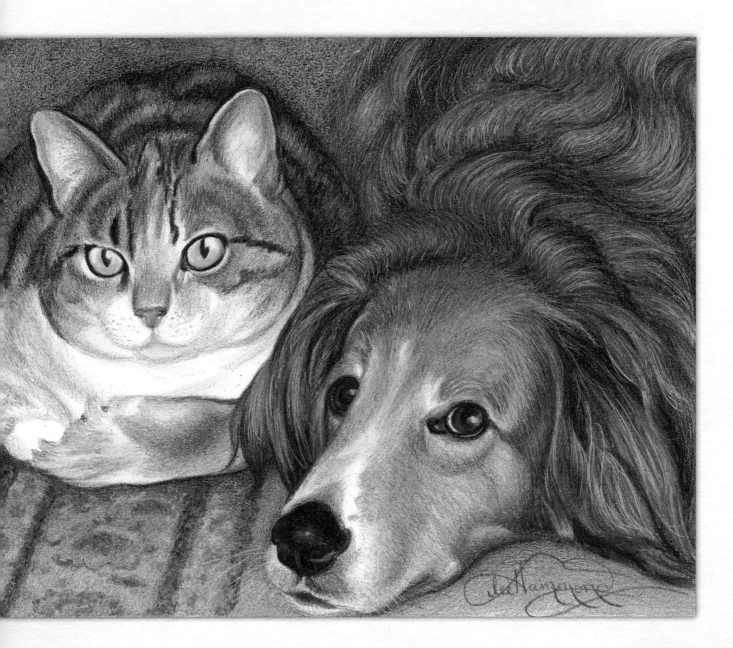

LIGHTING AND REALISM

This is an excellent example of what extreme lighting can do for a drawing. The deep shadow on the underbelly of the flamingo is due to the bright sunlight coming directly from above. The light is also reflecting off of the grass that surrounds the bird, creating beautiful bands of various shades of green.

While the patterns in the grass appear to be going horizontally, the last layer of the crayon was applied vertically, with tiny lines scratched out to enhance the look of the grass. Scratching was also used in the flamingo to create delicate feather patterns.

Flamingo
Crayon on Stonehenge paper
14" × 11" (36cm × 28cm)

COLORS USED: (flamingo) Antique Brass, Atomic Tangerine, Banana Mania, Black, Carnation Pink, Outrageous Orange, Peach, Red, Sunset Orange; (grass) Antique Brass, Black, Green, Green Yellow, Inchworm, Olive Green, Pine Green, Spring Green, Yellow, Yellow Green

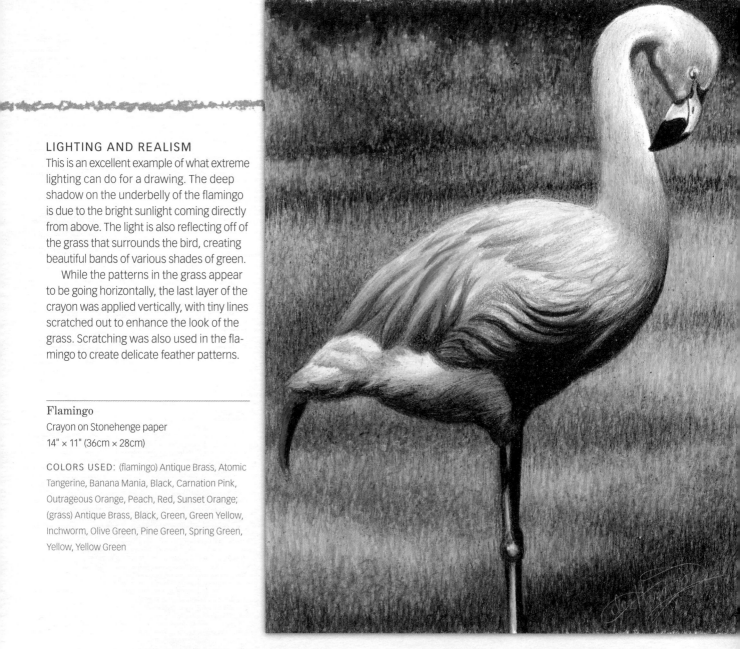

COMBINE TECHNIQUES

I used layering, burnishing and scratching techniques to create the various tones and textures in this drawing.

For those of you who are familiar with my other drawing and painting books, you probably recognize my best friend, Penny the Wonder Dog. This is a day in the life of Penny with her best pal, Mindy.

Penny and Mindy, Best Friends
Crayon on Stonehenge paper, 11" × 14" (28cm × 36cm)

COLORS USED: (Penny) Black, Bittersweet, Brick Red, Brown, Burnt Orange, Chestnut, Goldenrod, Sepia, White (eye highlight); (Mindy) Beaver, Black, Brown, Burnt Orange, Chestnut, Goldenrod, Sepia, White (eye highlight); (rug) Black, Beaver, Blue Green, Brown, Plum; (background) Beaver, Black, Brown

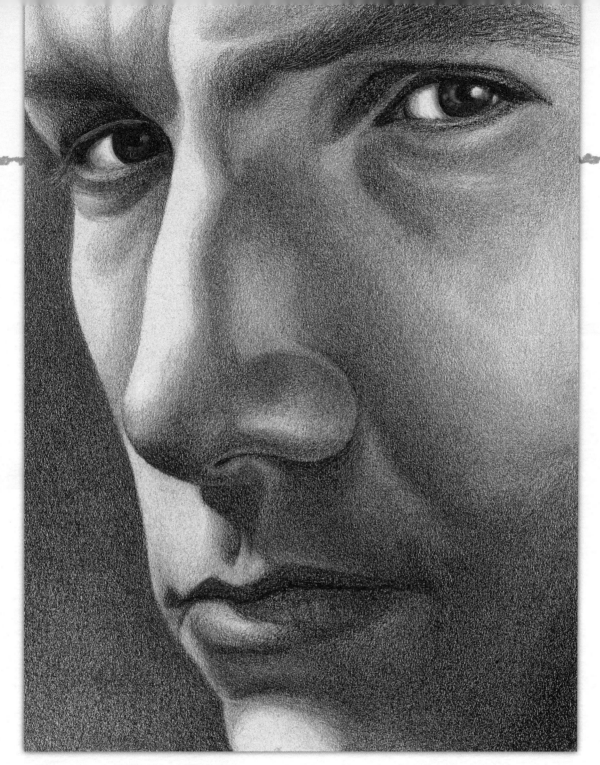

DRAWING IN MONOTONES DOESN'T HAVE TO BE DULL
In this example, I added some pastel colors for an unusual look. I had intended to render the entire portrait in only Black but the further I got, the more I wanted to bump up the color.

Blue Tones
Crayon on blue heather mat board, 16" × 12" (41cm × 30cm)

COLORS USED: (skin tones) Black, Orchid, Sky Blue, Vivid Violet, Wisteria;
(eyes) Black, Brown, White

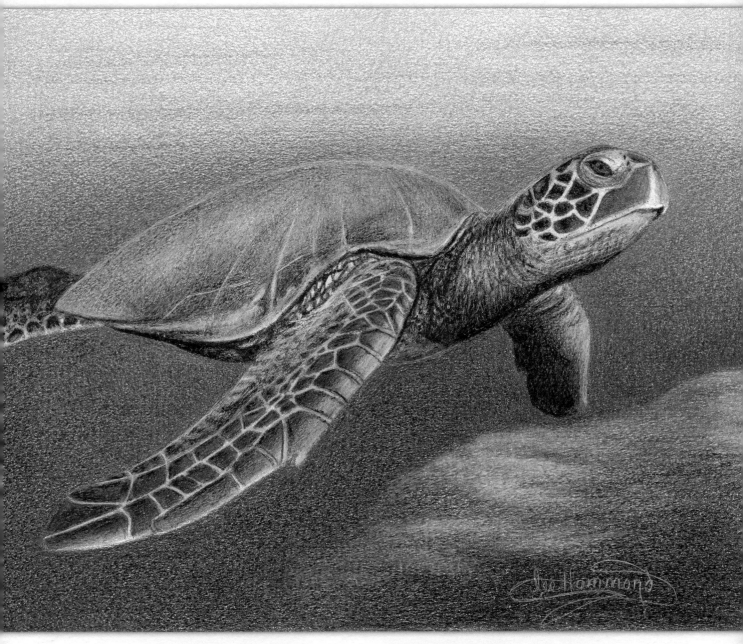

SCRATCHING CREATES TEXTURE
A lot of scratching was used to render the texture of the turtle's neck, chin, shell and flippers. When scratching with a craft knife, you must apply a light color first, so it shows when the darker colors applied over it are scratched off.

Sea Turtle
Crayon on Stonehenge paper, 11" × 14" (28cm × 36cm)

COLORS USED: (turtle) Black, Blue Green, Brown, Laser Lemon, Mahogany, Midnight Blue, Sea Green, Yellow; (background) Black, Blue, Blue Green, Midnight Blue, Sea Green

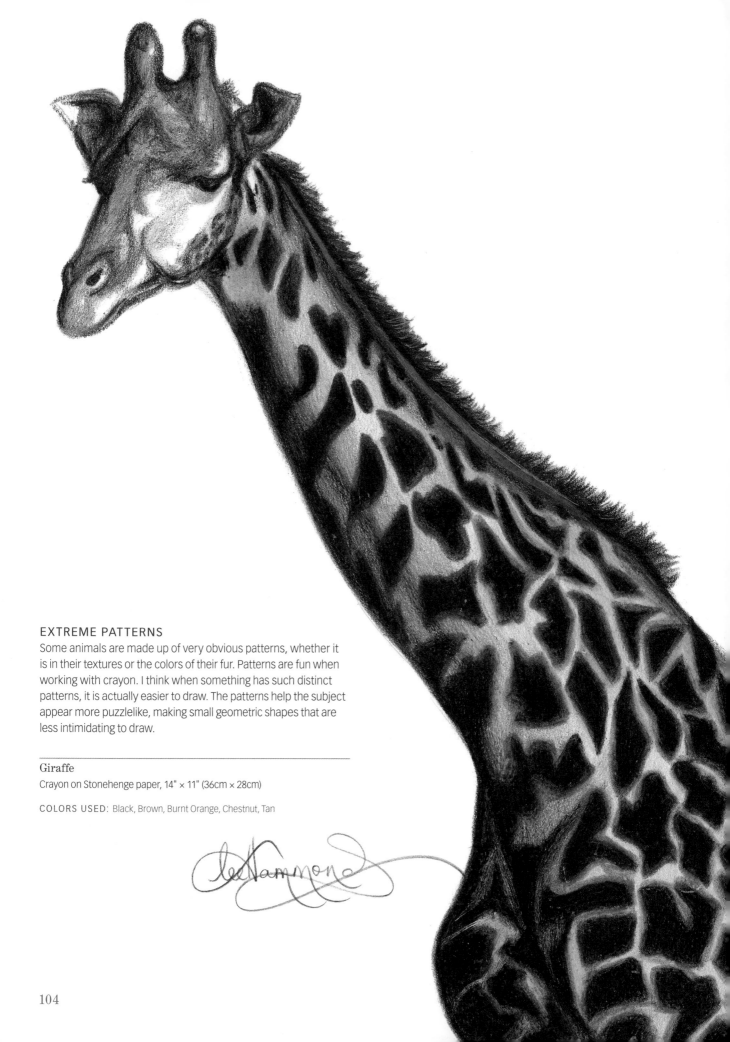

EXTREME PATTERNS

Some animals are made up of very obvious patterns, whether it is in their textures or the colors of their fur. Patterns are fun when working with crayon. I think when something has such distinct patterns, it is actually easier to draw. The patterns help the subject appear more puzzlelike, making small geometric shapes that are less intimidating to draw.

Giraffe
Crayon on Stonehenge paper, 14" × 11" (36cm × 28cm)

COLORS USED: Black, Brown, Burnt Orange, Chestnut, Tan

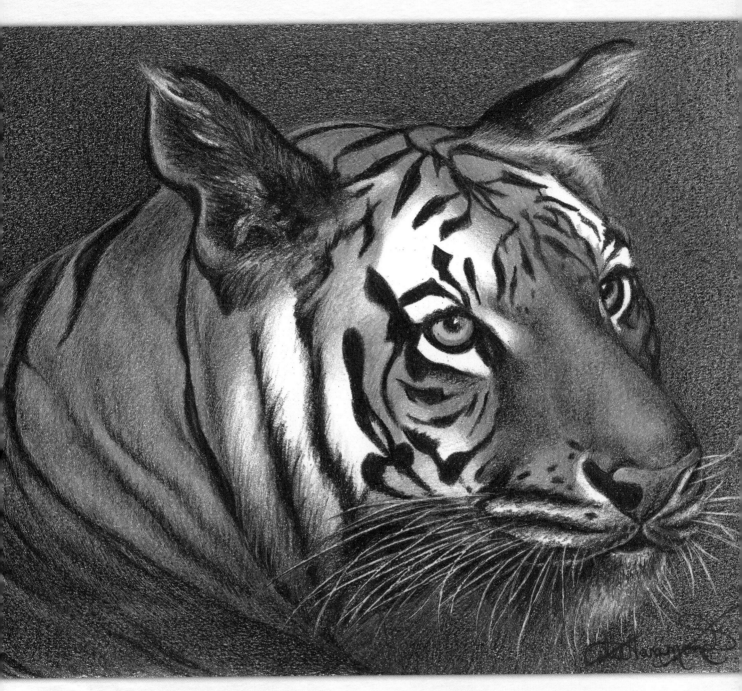

BACKGROUND ADDS DIMENSION AND CONTRAST

The background of this drawing, with its speckled appearance, make the subject matter more three-dimensional simply by contrasting with it. The color choice for your background is important. I picked the blue-green colors to enhance the orange colors in the tiger. Blue is the complement of orange, but I used the greener tones to reflect the true colors of nature.

Tiger
Crayon on Stonehenge paper, 11" × 14" (28cm × 36cm)

COLORS USED: (tiger) Bittersweet, Black, Brown, Burnt Orange, Melon, Orange, Yellow; (background) Black, Blue Green, Pine Green

Conclusion

IT IS HARD TO BELIEVE THAT CRAYON DRAWING CAN BE SO REALISTIC and enjoyable. I cannot help but believe that this book will forever change the impression of crayons and open a new and exciting door for children and adults alike. Hopefully, older students will fall in love with this book and the techniques within its pages, and they will pass the secrets along to younger students.

My happiest day will be years from now when I see the effects of this book in the art of students all over the world. I saw the artistic shift in pencil drawing when my first book was published many years ago. My pencil drawing used a new technique, and graphite was never the same again. It became hugely popular, and I now see my pencil techniques being used worldwide.

I feel the same thing happening here. It will be exciting for people to see these techniques, published here for the first time. I look forward to the future, but not just for me. I am excited for all of the people who will be inspired once again by their crayons, and who will find a whole new world to play in! I have no doubt that this will be one of many "coloring books" I will create over the years.

UNTIL NEXT TIME,

Reflection of Beauty
Crayon on Stonehenge paper, 16" × 12" (41cm × 30cm)

COLORS USED: (swan) Black, Blue Violet, Burnt Sienna, Carnation Pink, Mauvelous, Plum, Tan, Wisteria; (water) all of the above, plus Blue, Sky Blue, Violet

ABOUT THE AUTHOR

Lee Hammond has been a professional illustrator and art instructor for more than thirty years. She has been an author for North Light Books since 1994 and has published over twenty titles.

She is a certified police composite artist and is on call for the Kansas City Metro Area police departments as well as TV's *America's Most Wanted*.

She has illustrated many of the NASCAR® drivers, selling prints on QVC and NASCAR.com, and on her website, www.LeeHammond.com. Many of her art creations can be purchased from her online art gallery. She continues to add new art on a regular basis.

Lee's passion is and always will be teaching, and she currently teaches workshops full time nationally and internationally. She divides her time between Kansas City and Naples, Florida.

ACKNOWLEDGMENTS

I would like to thank my dear friend Kathy Kipp for helping me so much with this book. She was integral to this book becoming a reality. She had the ability to "see" my dream and its potential, and went to bat for me to have it produced.

I also want to thank my other friends at North Light, Pam Wissman and Jamie Markle, for their help and support as well. They are always there for me and willing to entertain my never-ending ideas, thus allowing me to continue my writing career. Thank you for always listening to me, and for your patience when I became overly persistent.

edited by Kathy Kipp and Christina Richards

designed by Jennifer Hoffman

page layout by Michelle Shi

production coordinated by Mark Griffin

Amazing Crayon Drawing with Lee Hammond. Copyright ©
2011 by Lee Hammond. Manufactured in China. All rights reserved.
No part of this book may be reproduced in any form or by any
electronic or mechanical means including information storage and
retrieval systems without permission in writing from the publisher,
except by a reviewer who may quote brief passages in a review. Pub-
lished by North Light Books, an imprint of F+W Media, Inc., 4700 East
Galbraith Road, Cincinnati, Ohio, 45236. (800) 289-0963. First Edition.

Other fine North Light Books are available from your
favorite bookstore, art supply store or online supplier.
Visit us at our website www.fwmedia.com.

15 14 13 12 11 5 4 3 2 1

Distributed in Canada by Fraser Direct
100 Armstrong Avenue
Georgetown, ON, Canada L7G 5S4
Tel: (905) 877-4411

Distributed in the U.K. and Europe by F+W Media International
Brunel House, Newton Abbot, Devon, TQ12 4PU, England
Tel: (+44) 1626 323200, Fax: (+44) 1626 323319
E-mail: postmaster@davidandcharles.co.uk

Distributed in Australia by Capricorn Link
P.O. Box 704, S. Windsor NSW, 2756 Australia
Tel: (02) 4577-3555

Library of Congress Cataloging-in-Publication Data
Hammond, Lee,
 Amazing crayon drawing with Lee Hammond / Lee Hammond.
-- 1st ed.
 p. cm.
 Includes index.
 ISBN 978-1-4403-0810-9 (pbk.)
 1. Crayon drawing--Technique. I. Title.
 NC855.H36 2011
 741.2'3--dc22 2010033331

Metric Conversion Chart

TO CONVERT	TO	MULTIPLY BY
Inches	Centimeters	2.54
Centimeters	Inches	0.4
Feet	Centimeters	30.5
Centimeters	Feet	0.03
Yards	Meters	0.9
Meters	Yards	1.1

Index

A

Acetate graphs, 15
All about crayons, 6
Animals. *See also* Birds
 brass horse, 59–61
 cat, 100
 dogs, 9, 23, 84–85, 100
 fish, 5, 6, 20–21
 giraffe, 104
 lion, 88–89
 panther, 86–87
 ram, 90–91
 sea turtle, 103
 tiger, 105
 tree frog, 78
 zebra, 4–5
Apples, 3, 36
Applying crayons, 7
Artagain paper, 9, 14, 92–93

B

Background, 20, 40, 65, 68–69, 71, 83, 92, 93, 105
Ball. See Sphere
Beach ball, 30
Before and after, 8–9
Betta fish, 20–21
Birds
 cardinal, 79
 flamingo, 101
 hawk, 82–83
 macaw, 79
 swan, 106–107
 Tiger Swallowtail, 22, 67–69
 toucan, 80–81
Black color, 23, 28, 66, 68, 69, 71, 80–81
Blue Tones, 102
Border box, 78
Brass horse, 59–61
Bricks, 54–55
Bristol paper, 14, 21
Burnishing
 birds, 79
 brass horse, 61
 crayon removal, 41
 defined, 16
 facial features, 98
 flowers, 63
 glass drawing, 56–57
 peach, 7
 plums, 37–39
 technique, 16, 17, 20–22
 with white colors, 37
Butterfly, 22, 33, 66–71

C

Caitlynn, 99

Cast shadow, 26, 28, 29, 39
Cat, 100
Circles, 44
Clemens, Samuel (Mark Twain), 92
Close-Up of a Rose, 62
Close-ups, 20
Color
 black, 23, 28, 66, 68–69, 71, 80–81
 color finders, 15
 color profile, 96–97
 color theory, 23
 color wheel, 24, 25
 complementary colors, 24, 25, 70, 72–73, 105
 cool colors, 13, 24
 experimentation with, 10
 light colors applied first, 36, 66, 71, 80
 pigment characteristics, 10
 primary colors, 24
 secondary color, 24
 shades and tints, 24
 transparency, 10
 warm colors, 12, 13, 24
Complementary color, 24, 25, 70, 72–73, 105
Conch shell, 50–51
Cone, 27
Contrast, 22
Craft knife, 15, 41, 53, 69, 72
Crayola Crayons, 5, 6, 12–13
Crescent mat board, 8, 14, 63
Cylindrical and round objects. *See also* Sphere
 apple, 36
 cylinders, 27
 drawing cylinders, 43
 drawing through, 46–47
 ellipses, 44–47
 everyday cylinders, 42
 layering for simple shapes, 36
 long cylinder, 27
 plums, 37–39
 teapot, 40–41

D

Dogs, 9, 23, 84–85, 100
Drafting brush, 15, 16, 69, 80
Drawing of a Hibiscus, 63
Drawing of a Ram, 90–91
Drawing of a Red Day Lily, 63
Drawing of a Tree Frog, 78
Drawing of an Ice Cream Cone, 42
Drawing through, 46–47

E

Egg, 27, 52
Ellipses, 44–47
Equal quarters rule, 45
Erasers, 14–15

Everyday cylinders, 42
Eyes, 79–85, 87, 94, 98

F

Faces. See Animals; People
Feathers, 79–83, 101
Female Cardinal, 79
Figure drawing, 60
Fish, 5, 6, 20–21
Five elements of shading, 26, 27, 62
Fixative not necessary, 21
Flamingo, 101
Flowers
 before and after, 8
 complementary colors, 25
 day lily, 63
 drawing, 62–65, 67–69
 hibiscus, 63
 Lavender Vase With Flowers, 10–11
 rose, 62
Foreshortening, 44
Full light, 26
Fur, 9, 17, 84–85, 89–91

G

Giraffe, 104
Glass, 56–57
Grid method, 15, 32–35

H

Hair, 9, 84–85, 87–89, 95
Halftone, 26, 28, 29
Hawk, 82–83
Heart, 31
Here's Looking at You!, 98
Horse, 59–61

J

Jars, 46–47, 56–57

K

Kissy Face!, 98
Kneaded eraser, 14

L

Landscapes, 72–73
Lavender Vase With Flowers, 10–11
Layering
 bird drawings, 79
 building dimension, 35, 85
 butterfly, 70–71
 defined, 16
 facial features, 98
 flowers, 63
 glass drawing, 57
 lion drawing, 89

Layering (continued)
 metal, 58
 mountain scene, 76–77
 on a peach, 7
 simple shapes, 36
 start with light colors, 36, 66, 71, 80
 teapot color, 40
 technique, 16, 17, 18–19
 for texture, 49
 tree frog, 78
Lighting, 26, 101
Lion, 88–89

M
Macaw, 79
Masking tape, 15
Mat board, 8, 14, 63
Materials, 14–15
Mechanical pencil, 15
Metal, 58–61
Midtone, 61
Mind's eye, 9
Monotone portraiture, 93–95, 102
Mountain landscapes, 73, 76–77
Mountain Scene, 73
Muscular form shading, 61
My Favorite Decanter, 56

N
Nature
 butterfly, 66–71
 flowers, 62–65, 67–69
 landscapes, 72–73
 mountain landscapes, 73, 76–77
 sunset, 72, 74–75

O
Oranges, 27

P
Palm tree, 75
Panther, 86–87
Paper, 9, 14, 17, 21, 92–93
Patterns, 55, 91, 104
Peach, 7
Pear, 34–35
Penny and Mindy, Best Friends, 100
Penny the Wonder Dog, 9, 23
People
 Blue Tones, 102
 Clemens, Samuel (Mark Twain), 92
 color portraiture, 99
 color profile, 96–97
 fun features, 98
 monotone portrait, 94–95
 Nicholson, Jack, 93
 Twain, Mark, 92
 triangle of features, 94

Photographs, drawing from, 15, 32, 92
Pink Pearl eraser, 15
Plums, 37–39
Plush Dog and Bricks, 54
Portrait drawing. See People
Portrait of a Macaw, 79

R
Rainbow trout, 5, 6
Ram, 90–91
Reflected light, 26
Reflection of Beauty, 106–107
Ridges, 91

S
Sand dollars, 48–49
Saturn, 30
Scratching
 bird drawings, 79
 defined, 16
 dogs, 85
 lion hair, 89
 mountain landscapes, 73
 sea turtle, 103
 technique, 16, 17, 20–21
Sea Turtle, 103
Shading
 bricks, 55
 defined, 24
 five elements, 26, 27, 62
 muscular form, 61
 pear, 35
Shadow edge, 26
Shapes, 27
Sharp point on crayons, 78
Sharpener, 14
Silver Pitcher and Books, 58
Sphere. *See also* Cylindrical and round objects
 beach ball, 30
 in black, 28
 in color, 29
 face, 94–95
 plums, 37–39
 Saturn, 30
Still Life of a Bowl of Eggs, 52
Stone, 18–19
Stonehenge paper, 14, 17
Strathmore, 14
Study of a Green Bottle, 42
Study of a Place Setting, 45
Study of Apples, 3
Study of Balloons, 22
Study of Crockery, 47
Study of Plums, 37
Study of Yellow Apples, 36
Sunglow, 72
Sunsets, 72, 74–75

T
Tabletop, 17, 34, 41, 51, 52
Teapot, 40–41
Teardrop, 80
Techniques, 16–35
 burnishing, 16, 17, 20–22
 color theory, 23
 color use, 25
 color wheel, 24, 25
 contrast, 22
 grid method, 32–35
 heart, drawing 31
 layering, 16, 17, 18–19.
 pear, drawing, 34–35
 scratching, 16, 17, 20–21
 shading, 26
 shapes, 27
 spheres, 28–30
 transparency, 22
Teddy bear, 17
Textures
 animal, 90–91
 brass horse, 59–61
 bricks, 54–55
 conch shell, 50–51
 glass, 56–57
 metal, 58
 sand dollars, 48–49
 wood grain, 52–53
Three-dimensional, 26, 27, 31, 34, 61, 92, 105
Tiger, 105
Tiger Swallowtail, 22, 67–69
Tints, 24
Toucan, 80–81
Transparency, 10, 22, 57
Tree frog, 78
Trees, trunks, limbs and leaves, 43, 72–73, 75, 80–81
Triangle of features, 94
Tungsten steel handheld sharpener, 14

U
Undertone, 40, 60, 67
Union eraser, 15

V
Video clips
 Drawing Lifelike Portraits, 10, 99
 Painting Animals in Acrylic, 23, 58, 82

W
Wallpaper, 48, 63, 103
A Wealth of Sand Dollars, 48
White vinyl eraser, 15
Wood grain, 52–53

Z
Zebra, 4–5

Ideas. Instruction. Inspiration.

These and other fine North Light products are available at your local
art and craft retailer, bookstore or online supplier. Visit our websites at
www.artistsnetwork.com and www.artistsnetwork.tv.

Lifelike Drawing With Lee Hammond
ISBN-13: 978-1-58180-587-1
33058 • paperback • 160 pages

Drawing Lifelike Portraits With Lee Hammond
ISBN 13: 978-1-60061-816-1
Z5350 • DVD running time: 90 minutes

Find the latest issues of *The Artist's Magazine*
on newsstands, or visit www.artistsnetwork.
com/artistsmagazine.

Recieve a **FREE** gift when you sign up for our **FREE** newsletters
at **www.artistsnetwork.com/newsletter_thanks.**

VISIT **ARTISTSNETWORK.COM**
& GET JEN'S NORTH LIGHT PICKS!
Get free step-by-step demonstrations along
with reviews of the latest books, videos
and downloads from Jennifer Lepore, online
education manager at North Light Books.